American Prints
1879-1979

American Prints
1879-1979

Catalogue of an exhibition at the
Department of Prints and Drawings
in the British Museum, 1980

by Frances Carey and Antony Griffiths

BMP Published for the
Trustees of the British Museum by
British Museum Publications Limited

Published for the Trustees of the British Museum by
British Museum Publications Limited

Cover: Bellows, *A Stag at Sharkey's* (cat. 56)
Back cover: Lichtenstein, *Brushstrokes* (cat. 127)

© 1980 The Trustees of the British Museum
ISBN 0 7141 0776 X

Published by British Museum Publications Ltd,
6 Bedford Square, London WC1B 3RA

Set in Monotype Bembo by S. H. Elder (Typesetters)
Ltd, Beverley, North Humberside, and printed in
Great Britain at the University Press, Oxford, by
Eric Buckley, Printer to the University

British Library Cataloguing in Publication Data

British Museum. *Department of Prints and Drawings*
 American prints, 1879–1979.
 1. Prints, American – Catalogs
 2. British Museum. Department of Prints and
 Drawings – Catalogs
 I. Title II. Carey, Frances III. Griffiths, Antony
 769'.973 NE505

 ISBN 0 7141 0776 X

Contents

6 Preface

8 Introduction

20 Alphabetical list of artists

21 Catalogue

54 Technical glossary

55 Bibliography

57 Plates

Preface

This exhibition of American prints of the past hundred years is the result of new policies recently adopted by the Department of Prints and Drawings and the Trustees of the British Museum. The prints fall roughly into the three groups of Whistler and his followers, the period between the two Wars, and the 1960s and 1970s. Almost all the works in the first section have long been in the Museum's possession; those in the other two have, for the most part, been purchased within the last year.

The introduction to the catalogue of the 1978 exhibition of late nineteenth-century French lithographs, entitled *From Manet to Toulouse-Lautrec*, drew attention to the deficiencies in the Museum's collection of twentieth-century prints and drawings. The purchases catalogued here represent an attempt to rectify this situation in just one important area. American artists have largely dominated printmaking from 1960 onwards, and the prints of this period have been acquired with a special fund designated for the purpose of building up a small collection of post-War prints of high quality. This has been done with a careful regard to the Victoria and Albert Museum and Tate Gallery, since it is our intention to complement and not to duplicate their collections. These are already strong in certain areas, and this explains the lack of balance that some may find in our choice. A few of the more important gaps will, however, be filled in the exhibition itself by several prints kindly lent by their owners.

We have been able to approach our ideal more nearly in the choice of the prints of the 1920s and 1930s, although we have made no attempt whatsoever to be comprehensive. American art of this period is hardly ever to be found in European collections, and this is probably the only extensive group of items anywhere this side of the Atlantic. They show subjects and approaches unparalleled in European prints of the same time. Since they present many similarities with the photography of the period, we hope to include a few of these in the exhibition. Although they cannot be described here, we would like to thank Michael Kauffmann and Mark Haworth-Booth of the Victoria and Albert Museum for agreeing to lend them to us.

Our work has been greatly assisted by many colleagues in American museums, and especially those in Providence, Boston and Philadelphia, who allowed us to spend several days examining their collections. Particular thanks are owed to Diana Johnson, Ellen Jacobowitz, Kneeland McNulty, Sue Reed and Barbara Schapiro, as well as to Gail Levin of the Whitney Museum of American Art in New York. Richard Field put himself to much trouble in helping us in our choice of modern works. We must also express our gratitude to the dealers, for their willingness to ship large numbers of prints to England on approval, and their endeavours to obtain the material we desired at short notice.

The catalogue has had to be written in considerable haste; the task would have been impossible without the kind help of the staff of the Tate Gallery Print Department and Library and the permission to use

their superb resources. We must thank the staff of British Museum Publications for taking on this book at very short notice, and Graham Javes and the Museum's Photographic Service for their swift service. Finally we would like to acknowledge the support we have received from the Director and Trustees of the Museum, which has made possible the acquisitions on which this exhibition depends, and the enthusiasm of the Keeper of the Department.

Introduction

The last hundred years have seen a remarkable transformation in the position of original printmaking in the United States. A century ago American prints gave but a feeble reflection of European work; now they have reached a position of world dominance. The fundamental reason for this is that the course of original printmaking has always been closely tied to that of painting: prints are two-dimensional images in the same way as paintings, and the expectation is that a good painter will be able successfully to turn his hand to printmaking if suitably motivated. Since in these last hundred years American painting and sculpture have moved from the provincial to the mainstream, it might seem inevitable that printmaking follow the same progression. But such a progression depended on the necessary conditions being satisfied. Two of the most important of these were the existence of a fund of technical expertise, and of a sympathetic climate of opinion.

The technical expertise was abundantly available. Although in 1879 few artists were making original prints (that is prints which are made by artists and are not reproductions of other works), American reproductive printmakers of the nineteenth century were renowned across the world for their skill in copying paintings or photographs in the various media of commercial reproduction. The wood-engravers attached to such magazines as *Scribner's* or *Harper's Bazaar* possessed formidable skills, and one of them, Timothy Cole, devised an astonishingly exact formula for engraving Old Master paintings. In lithography the firm of Currier and Ives published hundreds of prints of topographical, historical or satirical subjects which were unsurpassed in skill by anything in Europe at the time. In line-engraving too, and the later off-shoot of reproductive etching, there were impressive native practitioners, although many prints were also imported directly from Europe: a surprising number of nineteenth-century British and French prints were published with additional lines of lettering to establish a copyright in America.

This leads to the second necessary condition: the existence of a sympathetic climate of opinion towards printmaking, which has been assured by the popularity of prints, both old and new, among American scholars, collectors and museums. By the end of the nineteenth century important collections of Old Master prints were publicly available at Harvard, Boston and Philadelphia (Pennsylvania Academy), and S. P. Avery had given to the New York Public Library what is still probably the best collection of nineteenth-century French prints in the world. This interest in prints has been maintained throughout the century covered by this catalogue. At the present time, there are perhaps a dozen American public collections of prints of international importance with many other significant smaller ones, and print scholarship is to a large extent an American preserve. Admittedly this has been accentuated by the virtual disappearance of scholarly and public interest in prints in Britain, and, to a lesser extent, Europe since the 1930s, but the presence of an interested and critical public has

undoubtedly been a vital contributory factor in the flowering of the American print.

The first impetus to original etching in America was given by the so-called 'etching revival' of the 1860s in France and England. The New York Etching Club was founded in 1877, but the resulting prints were generally poor, amounting to little more than pale imitations of Jacque, Daubigny and the other Barbizon etchers. A curious case is Winslow Homer (1836-1910), a highly original painter, whose few large etchings are all reproductive in intention, often printed on unpleasant simili-Japan paper and altogether unsatisfactory in effect. This period was, however, one of unprecedented internationalism in American outlook, when visits to Europe and cultural ambitions became obligatory for all who could afford it. It is not surprising, therefore, that the best American prints were made in Europe by artists who were wholly or partly expatriate. The most extreme case of cultural assimilation is Mary Cassatt, whose drypoints fit comfortably into the French tradition. Whistler, however, transcends these categories and his work shows a constant and impressive originality.

Whistler made his reputation as a printmaker with the group of etchings made in France and England between 1858 and 1862. This exhibition, however, begins with the etchings of his middle period, the Venetian series made in 1879-80, because it contains his most original contribution to printmaking which was to be of such importance to his numerous followers and imitators. His lithographs have been excluded because we cannot document their influence (on Childe Hassam and others) as fully. The originality of the Venetian series of etchings lies in their dependence upon careful inking to produce the intended effect. Earlier etchers, notably Rembrandt, had varied the effect of a plate by inking and wiping it in different ways, but Whistler was the first to create plates which would be incomplete without such wiping. Foregrounds were left blank, and the recession of sea or land conveyed by graduated films of ink. This style was brilliantly suited to the nature of Venice, but less so to more earth-bound subjects. Whistler himself realised this, for in his later Amsterdam series of 1889 he began again to etch more on to the plate and rely less on effects derived from inking.

Whistler's etchings and lithographs gained an acceptance from the public that his paintings never really obtained, and by the end of his life he was widely hailed as the greatest living etcher. So it is not surprising that his influence was enormous on etchers of all nationalities, Americans included. Followers to be seen in this exhibition include Joseph Pennell, his pupil and biographer, and J. W. J. Winkler. Keeping a certain distance, but still decisively influenced by him, are J. Alden Weir and Maurice Sterne.

The widespread adulation of Whistler created the feeling that contemporary etchings could match the best ever produced in the past, and what can only be described as a 'boom' of academic etching set in across Europe and America. The practitioners were specialist print-

makers, and the most famous were Englishmen and Scotsmen, such as D. Y. Cameron and Muirhead Bone, whose subjects were almost invariably landscapes. Much of their work was purchased by American museums and collectors, and most American writers on printmaking throughout the 1920s and 1930s acknowledge the pre-eminence of these now little-known masters. The concentration on mastery of technique at the expense of any real interest in content is typical of this etching movement, which was international in its ramifications. Its best transatlantic practitioner was probably D. S. MacLaughlan, Canadian by birth, but based in Boston, while the best-known was the depressing virtuoso J. T. Arms. Both spent much of their time in Europe and concentrated mainly on European subjects in landscape and architecture. Another etcher who had an astonishing reputation in the period was F.W. Benson, whose prints, with very few exceptions, are of flying ducks.

It is often stated that this market in original etchings was killed by the Crash of 1929 and the resulting Depression, but this was not the case either in Europe or America. Life certainly became more difficult for the individual printmaker (the best account of this is in F. A. Comstock's book on F. L. Griggs), but the momentum and public interest were maintained to the end of the Second World War, when the rise of Abstract Expressionism suddenly began to make the entire pre-War printmaking tradition look quite obsolete. The 1920s and 1930s were the heyday of the numerous Print Clubs, mostly founded around the First World War, of which there seems to have been one in most American cities, often with close links with the local museum; they held competitions, offered substantial prizes and commissioned prints for distribution to members. A specialist American magazine entitled *Prints* (a parallel to the *Print Collectors' Quarterly* in Britain) was published from 1930 to 1938. A final sign of vigour was the spread of the highly academic and specialist craft of wood-engraving to America; this is represented in this exhibition by the work of Nason and Cheffetz, both of whom only turned professional around 1930.

However charming their work, such specialists drove themselves into a cul-de-sac of technique, while their subjects drifted steadily away from the artistic preoccupations of the painting of the period. The best criticism of such an approach was made by Edward Hopper about one of his contemporaries: 'It seems to me that he is more interested in the graces of etching's methods than in having something of his own to say. If etching were merely a craft, he would be a very good etcher, but we know it can and should be a means of self-expression'. The excitement and interest of many of the prints of which we shall now speak is precisely that they *were* made by artists with something of their own to say.

At this point it may be useful to give a summary of the course of American painting up to the Second World War, in so far as this can be done in a short space. The large numbers of French Impressionist paintings imported into America from the 1870s onwards soon had

their influence on artists, and the main public manifestation of the American 'Impressionists' was the exhibition of 'The Ten' in 1895; they included Weir, Twachtman and Childe Hassam. Their art grew naturally out of what had gone before, and they were never seen as iconoclasts or revolutionaries in the way that 'The Eight' were on their exhibition in Philadelphia in 1908. These were a group of artists, mostly newspaper illustrators in their origins, who took their lead from the teaching and example of Robert Henri. Their subjects were taken from everyday life, and for this reason they were dubbed the 'Ash-Can' school. John Sloan was a leading light, and George Bellows was closely linked to them. The Ash-Can school is the first American artistic movement which was not largely European in inspiration. The next major event, however, the Armory Show of 1913, saw the wholesale importation of major works by almost all the leading members of the European avant-garde. This had an explosive effect on American painters, and between about 1915 and 1927 many of them devoted their energies to the attempt to come to terms with European Modernism. A minority however turned their backs on these innovations, sticking to American traditions and American subject-matter. There was of course much cross-fertilisation between the two streams. By the time of the Depression of the 1930s, the painters of the 'American scene' (as they were generally called), especially the Regionalists, had almost completely ousted abstract or modernist painters from public notice. The Second World War put an end to this. Attention was again drawn to Europe, and the presence of many exiled Surrealists in New York provided the catalyst for a new wave of abstraction, which came to dominate painting all over the world in the late 1940s under the label of 'Abstract Expressionism'.

All these movements had their effect on the course of printmaking, although in different ways and with varying achievement. Weir's etchings were made before he decisively lightened his palette under French Impressionist influence, and the outstanding etcher in an 'impressionist' manner was Childe Hassam. He had long established his position as one of the most famous American painters when he took up etching in 1915 at the age of fifty-six. Here his success was remarkable, for he managed to create a system of squiggled hatching which makes his most famous and best print, the *Lion Gardiner House* (cat. 37) one of the most surprising triumphs in the history of etching. It is unfortunate that most of his work came nowhere near the same standard.

The only one of the eight members of the Ash-Can school to take up printmaking seriously was John Sloan, whose work is well represented in the British Museum thanks to his widow's generosity in presenting a group of twenty-five of his etchings in 1965. Although Sloan was not a great painter, his prints are very impressive achievements and are of fundamental importance in the history of American printmaking, standing as they do at the head of the whole flourishing tradition of 'American scene' printmaking; in 1927, for example, Hopper wrote a

long article in their praise. Sloan's preferred medium was etching which he practised throughout his career. His subjects cover a wide range – fashionable ladies on Fifth Avenue, working class interiors, Coney Island beach – and show his warm response to anecdotal incident that betrays his training as an illustrator.

The only other important printmaker linked with Sloan and the Ash-Can school is George Bellows, one of the most interesting and forceful personalities in the history of American art. Bellows never made an etching but took to lithography in 1916, long after his position as a painter had been established. At that moment, lithography seems to have been regarded in America almost entirely as a commercial process, and there are very few records of other artists practising it. Bellows was led to it by a curious route: he began to use lithographic crayon in his drawings around 1910 and, liking its richness of texture, was soon employing it to the exclusion of other materials. The logical development from this – the making of actual lithographs – followed when Bellows installed a press in the studio at his home, and employed a printer to come in and help him. Many of his prints, including the most famous of all, the *Stag at Sharkey's* (cat. 56), repeat the composition of earlier paintings, but curiously the lithographs are often more successful. Bellows was a superb draughtsman and his feeling for the textures of lithographic chalk and wash has seldom been equalled; his paintings, however, are often marred by weak colouring and a certain discomfort in handling oil paint. His subjects cover a range unusually wide for an American, from pure comedy in the *Business-men's Bath* (cat. 58) to horrific pictures of German atrocities in Belgium.

Very few prints are known by any of the Modernists of the period of the Armory Show. The most familiar are the etchings by John Marin of the Woolworth Building, seen in the manner of Robert Delaunay, in a state of partial collapse. The only one of these artists represented here is Max Weber, whose woodcuts derive both from Expressionism and primitive art. There is nothing surprising in these artists' lack of interest in printmaking. They probably thought printmaking a medium too hide-bound in its traditions, and in the case of etching there is the further point made by Hopper: 'The practitioner struggling to bend the medium to serve his ends realises to the full the difficulty of plastic generalisation in so meticulous a process as etching.' The same lack of interest persisted among the most 'advanced' painters of the 1920s and 1930s, and the few such prints as were produced were, perhaps inevitably, lithographs. The most significant are perhaps those by Louis Lozowick, an interesting artist who worked in Berlin during the early 1920s and was associated there with El Lissitsky and other Russian Constructivists. During these years El Lissitsky was making some remarkable lithographs, and the best prints that Lozowick made after his return to America in 1925 were certainly influenced by these. The only other prints in this exhibition which show any concern with Modernism are the lithographs by the

Precisionist Charles Sheeler and those of the isolated figure of Stuart Davis.

By contrast the various artists loosely grouped together as painters of the American scene enthusiastically adopted printmaking, and most of the prints in this section of the exhibition belong to this group. American scene painting and printmaking is properly a phenomenon of the 1930s, but it had vitally important forerunners in the 1920s. These were Hopper and Martin Lewis, two of the finest of all American printmakers, although it will surprise many to find their names coupled in this way. Hopper is now perhaps the most famous American painter of his time, while Lewis is unknown to histories of art. This is because his paintings and watercolours never achieved any success (and, so far as we can judge, did not deserve to), and his reputation was confined to the specialist print-collecting public.

Hopper was born just north of New York and spent most of his life painting in the city during the winter and in the country around Cape Cod in the summer. Although born in the same year as Bellows, he took much longer to reach artistic maturity. All his fifty or so etchings were made between 1915 and 1923, when he was earning a living by illustrating journals, and adumbrate the themes which dominate his later painting. Hopper later stated: 'After I took up etching, my painting seemed to chrystalise.' The British Museum is fortunate in possessing four of his finest prints, all purchased by the former Keeper of the Department, Campbell Dodgson, and presented in 1926. This is astonishingly early as Hopper only began to make a reputation in America itself in about 1923, and even now is very little known in Europe. Of Dodgson's many brilliant coups for the Museum, this will come to be recognised as perhaps the most inspired as Hopper takes his rightful place among the great etchers of this or any century.

The four prints all show the emotional tension that is the hallmark of Hopper's art. The *East Side Interior* (cat. 63) conveys the alarmed surprise of the woman sewing; the cause of her alarm is quite obscure, but her edginess charges the whole innocuous scene with implied danger. Similarly in the *Evening Wind* (cat. 61) a curtain idly blows into a room, and somehow constitutes a threat to a naked woman climbing into bed. *Night on the El-Train* (cat. 60) shows the mysterious intimacy of two passengers whom the emptiness of the car has forced into a conspiratorial huddle. Light is of fundamental importance to all Hopper's art and is one reason for his success in the black and white medium of etching. The preliminary drawings are invariably in black charcoal, and he took his most ambitious prints through a succession of states (often as many as eight), building up layers of shadow or scraping them down until he had achieved the right balance. In technique he is one of the most intelligent disciples that Rembrandt ever had, and in this he stands quite apart from any of his American contemporaries. He also greatly admired Charles Meryon, whose brooding and even morbid views of Paris certainly influenced him. After 1923, when he abandoned etching in favour of painting and watercolour, his art continued

to grow in subtlety. Figures were frequently eliminated altogether and by painting buildings with an acute sensitivity to different architectural forms, angles of vision and types of light, he conveyed a feeling of urban desolation with an implied description of human life. In this Hopper's nearest – and most unlikely – successor is the Super-Realist Richard Estes, who uses shop windows filled with a thousand reflections in deserted streets to similar effect.

Martin Lewis, a friend of Hopper, was a year older. Born in Australia, he emigrated to America at the age of nineteen. He also began etching in 1915, and is said to have given Hopper advice in his earliest efforts. He produced nearly 140 prints between then and 1939; after that, excepting a few prints, he abandoned the medium and lived in obscurity until his death in 1962. It is only in the last few years that his reputation has begun to revive. Lewis is the poet of New York and without the stimulus of the city his art invariably and embarrassingly collapses: his views of Japan and his figure studies are distressingly poor. Lewis spent much of his time wandering round the streets of the city, observing its life and absorbing its atmosphere. His really successful prints (and there are only a few dozen of these in all) use abnormal lighting or weather conditions to accent the abnormality of the city. The best are his night scenes: small black figures seen in acute foreshortening pass in silhouette before lighted shop windows, or cast huge shadows. Other prints depict the raking glare of the morning sun or the still whiteness of settled snow. Unlike Hopper's, Lewis's work is usually topographical, or at least has a specific sense of location. Figures serve as counterpoint to their setting, and the emotional tension found between them in Hopper is diluted or lacking altogether in Lewis. Although he is undoubtedly the lesser figure, Lewis's urban landscape is immensely evocative and very original.

In the 1930s artistic and critical interest concentrated to an astonishing degree on art related to the American scene. This is unquestionably related to the Depression; the consequent preoccupation with America's own internal conditions could find no place for the internationalism of the post-War era. One aspect of this was the New Deal programmes of Government employment of artists. The first of these, the Public Works of Art Project, was inspired by the renown of the Mexican muralists of the 1920s (one print by Orozco is included in this exhibition (cat. 104)) and commissioned murals for public buildings. It was a condition of employment that the painting be representational and show some aspect of the American scene. The later Federal Art Project, under the Works Progress Administration, ran from 1935 to 1943. This included printmaking as one of its sections but laid no stipulations about content. Curiously, although a vast quantity of prints was produced (239,727 prints from 12,581 designs), it is difficult to say precisely what, if any, influence it had on the course of American printmaking. Certainly, it did not produce any masterpieces. The only apparent effect is that it introduced several new printmaking processes (silkscreen and the obscure 'carborundum' print), and this seems to

have been the first step towards the extraordinary search for technical innovation which is so characteristic of the first decade of printmaking after the Second World War.

Critical discussion of the period centred around two distinct varieties of American scene painting: 'Regionalism' and 'Social Realism'. The former is discussed in a later paragraph, but the latter must be mentioned briefly here. Social Realism was dominated by left-wing ideology, and the major figures were Ben Shahn, Philip Evergood and the Soyer brothers. All concentrated on the human figure; Shahn's images, such as his *Sacco and Vanzetti* were directly political, while the Soyer brothers showed a more general concern for the plight of the poor. This exhibition, however, includes no work by these artists. Instead it concentrates on the prints by the artists who have been grouped together as a 'Fourteenth Street' school. The name derives from their subject-matter: the people of the poorer working class districts of New York around Fourteenth Street. The three members shown here, Reginald Marsh, Peggy Bacon and Isabel Bishop, all studied at the Art Students' League in New York under Kenneth Hayes Miller, a painter and printmaker himself but of no great achievement, who played a similar role as did Henri for the members of the Ash-Can school. Miller's chosen subject was the human figure, and this dominates the work of the three artists shown here.

The senior of them, Reginald Marsh, is in many ways John Sloan's closest follower, and Sloan did in fact teach him for a period in the Art Students' League. He differs however in his detachment and jaundiced view of life. His preferred subjects are bums, drifters and other riff-raff, and his favoured setting is the interior of a strip joint; his success in capturing the gloating faces of the audience is astonishing. Many of his prints are menacing in character and it seems clear that it was Marsh's knowledge of Georg Grosz and the other masters of the German *Neue Sachlichkeit* that led him away from the sympathy and openness of Sloan. But in its place he achieved a certain monumentality, and Isabel Bishop characterised his etchings as 'austere and powerful and transparent'.

By contrast the world of Peggy Bacon is domestic, often dominated by cats. Her small-scale intimacy is usually humorous and always delicate and sympathetic in perception. The work of Isabel Bishop is concerned with the straightforward draughtsmanship of one or more figures seen in everyday poses. This might even be described as academic in approach, which may be a reason why her work has recently attracted renewed attention. The real achievement of these prints is the success with which they tackle apparently simple but in reality very difficult subjects, at a time when few others considered these problems of any interest at all.

The final group of works by artists of the 1930s included in this exhibition are the lithographs by the Regionalists – Thomas Hart Benton, John Steuart Curry and Grant Wood – all of whom found that lithography provided earthy textures suitable for their subjects. They

are really very different artists, but leapt into fame in the 1930s, becoming the most widely known painters of their day. Their admirers were responsible for grouping them together and using them as the leaders in a campaign for a 'true' American art against French art and its derivatives. Benton's aggressiveness when criticised led him into many ill-considered statements and so he substantially falsified his own and his fellow Regionalists' position. The effort to be an Iowan landscapist killed Grant Wood's talent which lay in rather hallucinatory portraits of provincialism. The *Shriner Quartet* in this exhibition (cat. 107) is the only print by him which has the same sort of quality as his early paintings such as *American Gothic*, a farmer and his wife in front of their 'Gothic' cabin. Curry was the least interesting of the three, although his technical and colouristic ability in handling paint is impressive. With his prints one has particularly acutely a feeling which often comes when examining Regionalist lithographs: that they are really reproductions of paintings and are not of much importance as prints. The Regionalists' success as painters obviously opened up a market for prints of similar themes, and, although lithography certainly suited their art, it is also a medium for which skill and commitment are not essential.

Of the three Regionalists, Benton is the most complex. He spent much of his time wandering around the obscurer parts of the United States, and wrote a fascinating account of his travels. He was obviously deeply impressed by the achievements of the Mexican muralists, but felt obliged to find a peculiar style for American subject-matter. This turned out to be a landscape with rhythms akin to those of jazz, and people imbued with a rather coarse folksiness. But occasionally he transcended these limitations, and *The Race* (cat. 106), in which a silhouetted horse races a train, is a wildly romantic and genuinely exciting image which stands as a symbol for the impractical but defiant obstinacy of spirit of the pioneers of the American West. But however archetypally 'American' this may now seem, the complexity of affiliations of the period is revealed by Benton's autobiography: in his early days in Paris, his greatest friend and the man who had the deepest intellectual influence on him was Stanton Macdonald-Wright, perhaps the most extreme American abstractionist of his generation, and the inventor of 'Synchromism', a transatlantic parallel to Delaunay's Orphism.

The end of the art of the American scene during the Second World War was very sudden. As fighting broke out in Europe and the Pacific, and as America, despite attempts to preserve her neutrality, was inevitably sucked in, preoccupation with domestic concerns began to look trivial or irrelevant. The epitaph on the period was appropriately pronounced by Jackson Pollock, a pupil of Benton and a Regionalist in the 1930s and the leader of Abstract Expressionism in the 1940s: 'The idea of an isolated American painting, so popular in this country during the thirties, seems absurd to me . . . An American is an American and his painting would naturally be qualified by that fact, whether he wills it or not.'

Jackson Pollock's own prints, which remained unpublished until 1967, typify the problematic relationship between painting and printmaking in America in the immediate post-War period. Pollock had studied with S. W. Hayter in 1944 when Hayter's studio, Atelier 17, was temporarily exiled to New York; the etchings Pollock produced revealed the same Surrealist agitation of line characterising his painting in the mid-1940s. These prints, however, remained an isolated and forgotten aspect of his work, failing to provide any impetus for further experimentation. The apparent limitations on scale and the deliberation of line imposed by intaglio methods, proved inimical to the expansive spirit of Abstract Expressionism.

During the late 1940s and 1950s, the *peintre-graveur* tradition, which has been crucial to avant-garde printmaking, was largely submerged in America by an obsessive concern with the means of execution. Interest in the technical apparatus of printmaking had been one of the salient features of the Graphic Art Division of the Federal Art Project before the War. Hayter's presence in New York fostered the craft orientation of American printmakers, introducing sophisticated intaglio methods and a vocabulary of Surrealist forms which encouraged the exercise of technical virtuosity for its own sake. After Atelier 17's return to Paris, further centres for the dissemination of these influences were established at Yale University, for example, under the aegis of the Hungarian artist, Gabor Peterdi, and at the University of Iowa, whose Graphics Workshop was run by the Argentinian, Mauricio Lasansky. The other repository of a long cumulative tradition, the woodcut, also enjoyed a certain pre-eminence, largely due to the work of Leonard Baskin, who perfected a means of executing vast figurative images in an Expressionist manner on sheets of plywood. These artists and their pupils were promoted by annual print competitions such as those held at the Brooklyn Museum in the 1950s, and were supported by the older collectors like Lessing J. Rosenwald, whose protégé, the Print Council of America, defended the *status quo* and resisted any apparent erosion of autographic printmaking.

The conservatism of the Print Council of America is suggested by their selection of prints of the year for 1962, with one significant exception: a startlingly unconventional image of a wire coathanger suspended against a densely shaded background. The print in question was one of Jasper Johns' first lithographs, published in 1960 by Universal Limited Art Editions. Tatyana Grosman, the founder of Universal Limited Art Editions in 1957, the Pratt Graphics Art Centre in New York established in 1956, and June Wayne's Tamarind Workshop opened in Los Angeles in 1960, sought to revive the '*peintre-graveur*' by creating the right conditions for a close collaboration between master printers and artists. Lithography was the medium on which they chose to concentrate their energies, since it permitted a spontaneity and painterliness denied to the intaglio practitioners by the linear complexities of their techniques.

The workshops mentioned above were responsive to the climate of avant-garde American painting which Robert Motherwell described in 1965: 'The large format, at one blow changed the century-long tendency of the French to domesticise modern painting, to make it intimate. We replaced the nude girl and the French door with a modern Stonehenge, with a sense of the sublime and the tragic that had not existed since Goya and Turner.' Of the older generation of abstract artists, Motherwell, De Kooning and Barnett Newman all published lithographs in 1960; only Motherwell, however, continued to become a major printmaker. It was the second generation of the New York School, represented principally by Jasper Johns and Robert Rauschenberg, who addressed themselves to printmaking with the greatest enthusiasm. By 1963 Rauschenberg had won an international award for a black and white lithograph entitled *Accident*, thereby establishing the credentials of the American change in attitude towards print media.

The 1960s witnessed the resurgence of objective art; Timothy Riggs has pointed out that Jim Dine, for example, one of the most prolific printmakers of the last two decades, took refuge in the depiction of commonplace objects, partly as an acceptable way of returning to representational drawing. The artists' choice of imagery marked their consciousness of a certain kind of American mythology, whose antecedents went back as far as the mid-nineteenth century, when Asher B. Durand had remarked *à propos* of his stay in Europe, that he would trade it all for the signboards of America. Stuart Davies had identified popular American culture as a major source of inspiration for his work, and Jim Dine paid a similar tribute to the beauty of billboards and gas stations as photographed by Walker Evans in the 1920s and 1930s and painted by Edward Hopper: 'I love the eccentricity of Edward Hopper, the way he puts skies in He is also a Pop artist – gas stations and Sunday mornings and rundown streets, without making it social realism.' ('What is Pop Art?', Interviews by G. R. Swenson, *Art News*, November 1963, p.61). In the same interview, Roy Lichtenstein defined Pop Art as 'industrial painting There are certain things that are usable, forceful and vital about commercial art. We're using those things – but we're not really advocating stupidity, international teenagerism and terrorism.' The refinements of traditional techniques seemed inappropriate to a vocabulary of strip cartoons, soup cans and the other paraphernalia of mass media, whereas the hitherto despised mechanical means of reproduction, silkscreen, stencil and photo-transfer were sufficiently removed from any hint of preciousness.

Silkscreen prints promised initially to be a democratic art form and the early work of Lichtenstein and Warhol was often produced quite inexpensively in large editions; Rauschenberg also published a lithograph, his *Visual Autobiography* of 1968, in an edition of two thousand. However, as the print boom of the 1960s gathered momentum, a distrust of facile reproduction and the innate snobbery of any

collectors' market began to assert itself; prints were coveted partly as substitutes for paintings and their purchasers wished to avoid too many invidious comparisons between unique and multiple works of art. Screenprinting, except insofar as it was an adjunct to more autographic methods, fell into some disrepute, rather as chromolithography had in France a century earlier. It was only when Jasper Johns demonstrated the painterly possibilities of the medium in recent years, or Richard Estes, the Photo-Realist, exploited the subtlety of its layered colours, that screenprinting recovered a measure of respectability. The criteria for an original print, as laid down by the Print Council in 1961, that it had to be conceived, prepared and executed by the artist, commanded a new attention at the end of the 1960s, associated with a gradual move away from planographic techniques to intaglio work. Jasper Johns' *1st Etchings* were executed in 1967–9, after Universal Limited Art Editions opened its intaglio studio and the Crown Point Press had established similar facilities in 1965 in Oakland, California. The prints they published differed dramatically from the hectic line and crowded compositions of Hayter's disciples. Johns, as might be expected, was interested in tonal effects (often achieved with a combination of soft-ground etching and aquatint) which would suffuse the entire composition. These techniques had a particular appeal for the highly conceptual work of the Minimalist artists, who desired an extreme purity of line and tone. The rejective nature of the content of their work led them to a positively sensuous attention to detail; the medium itself was, after all, the main point of distinction between their prints and their paintings or drawings. Brice Marden has alluded to this in relation to his own work: 'I wanted to arrive at a balance of line and colour, that would be true to the nature of my work, without being a duplication or imitation of painting or drawing. I feel something of the medium remains which makes them singularly interesting.' (Toronto exhibition catalogue).

During the past decade, printmaking has strenuously endeavoured to improve its position within the hierarchy of artistic expression. This has at times taken the form of a denial of the print's inherent two dimensionality, by imparting a sculptural quality to the work; technological advances have enabled the production of multiple lead reliefs and moulded paper objects among other eccentric interpretations of what constitutes a print. The campaign has been more widely conducted with the aid of increasingly subtle refinements of conventional printing techniques and a fascination for materials. The two artists whose work stands at the beginning and end of this exhibition, Whistler and Richard Estes, serve to remind us of how a correct balance can be achieved between exquisite physical means and an impressive visual image, to which end they must be subservient.

Alphabetical list of artists

	Cat. nos.		Cat. nos.
Arms, John Taylor	24 – 26	MacLaughlan, Donald Shaw	20 – 23
Bacon, Peggy	95	Mangold, Robert	133
Bellows, George	55 – 58	Marden, Brice	132
Benton, Thomas Hart	105 – 106	Marsh, Reginald	85 – 94
Bishop, Isabel	96 – 103	Motherwell, Robert	126
Borne, Mortimer	73 – 76	Nason, Thomas Willoughby	112
Cassatt, Mary	27 – 29	Nauman, Bruce	129
Cheffetz, Asa	113	Nordfeldt, Bror Julius Olssen	19
Cook, Howard	82	Orozco, Jose Clemente	104
Curry, John Steuart	108	Pennell, Joseph	14 – 18
Davis, Stuart	84	Rauschenberg, Robert	118 – 119
De Kooning, Willem	116	Riggs, Robert	114 – 115
De Martelly, John Stockton	111	Rosenquist, James	120
Dine, Jim	121 – 125	Ruscha, Ed	128
Estes, Richard	134	Ryman, Robert	131
Gag, Wanda	109 – 110	Sheeler, Charles	78
Hassam, Childe	36 – 37	Sloan, John	40 – 54
Hopper, Edward	60 – 63	Sterne, Maurice	39
Johns, Jasper	117	Weber, Max	59
Kupferman, Lawrence	77	Weir, Julian Alden	30 – 35
Lewis, Martin	64 – 72	Wengenroth, Stow	83
LeWitt, Sol	130	Whistler, James McNeill	1 – 13
Lichtenstein, Roy	127	Winkler, John William Joseph	38
Lozowick, Louis	79 – 81	Wood, Grant	107

Catalogue

In the catalogue entries references are given (where appropriate) to the standard catalogue of the artist's work; these are fully described in the *Bibliography* given after the biographical note on each individual artist.
Numbers in brackets prefixed by 'Lugt' refer to F. Lugt, *Les Marques de Collections*, Amsterdam, 1921, and its *Supplément*, The Hague, 1956.
An asterisk beside the catalogue number denotes an illustration in the plates section.

James McNeill Whistler

1834–1903

Born in Massachusetts. After early training at the West Point Military Academy, he went to Paris in 1855. In 1859 he moved to London where he remained for the rest of his life, becoming one of the dominating and always controversial figures in the English art world. He never however changed his nationality or ceased to regard himself as an American. In his painting Whistler moved from realism to an almost abstract decorativeness. He was equally well known as an etcher, and after being bankrupted by his libel action against Ruskin in 1878, he was commissioned to make a series of etchings of Venice. These were published in two sets, the first of twelve in 1880, the second of twenty-six in 1886. In these he broke away from the earlier style of his *French* and *Thames* sets of 1858–61, now often relying on effects deliberately created by leaving films of ink on the plate. This new manner often produced results of great beauty, and was enormously influential in Europe and America.

Bibliography E. G. Kennedy, *The etched work of Whistler*, New York, 1910; E. R. & J. Pennell, *The life of James McNeill Whistler*, London, 1908.

*1 San Biagio

1879–80 (*Second Venice Set*)
Etching and drypoint. 208 × 300 mm
1887-10-10-65. Presented by Messrs Dowdeswells and Thibaudeau
Kennedy 197, ninth state. Monogram on tab

This and other impressions come from a complete *Second Venice Set* presented by its publishers in October 1887. Whistler printed thirty sets for them between April 1886 and July 1887 on 'exquisite old Dutch paper', with twelve additional impressions of certain subjects, after which the plates were cancelled. A complete set was priced at fifty guineas. Of the first Venetian set of 1880, the Department unfortunately possesses only four prints. It is very difficult to arrange the Venice etchings in any chronological order, and here they are all put down to 1879–80 (the year Whistler was in Venice) unless there is good reason to be more specific.

2 Doorway and vine

1879–80 (*Second Venice Set*)
Etching and drypoint. 230 × 166 mm, and 233 × 170 mm
(a) 1929-12-14-7. Bequeathed by A. H. Studd, Esq.
Kennedy 196, fifth state. No tab or monogram; there is a repaired tear across the centre.
(b) 1887-10-10-63. Presented by Messrs Dowdeswells and Thibaudeau
Kennedy 196, seventh state. Monogram on tab

These two states of the same print show the minute changes that Whistler made as he worked on his plates. In the later state, the position of the figure in the doorway has been changed, the grid above the door narrowed, and the window above the grid scraped down. Whistler in fact never seems to have regarded any of his later plates as completely 'finished'; he continually retouched them in drypoint in the course of printing as they wore down. The main difference between these two impressions lies in the paper and the wiping: the first is heavily wiped on Japan paper, the second is clean-wiped on a Dutch laid paper. Whistler hardly ever in his later years used the ordinary commercially available papers, drawing instead on his large collection of fine old papers.

3 Turkeys

1879–80 (*Second Venice Set*)
Etching and drypoint. 207 × 129 mm
1887-10-10-67. Presented by Messrs Dowdeswells and Thibaudeau
Kennedy 199, second state. Monogram on tab

After 1879 Whistler always trimmed the margins of his prints himself, usually leaving a tab for his butterfly monogram. He explained the reason for this in the ninth of the *Propositions* issued with the *Second Venice Set*: 'That the habit of the margin, again, dates from the outsider, and continues with the collector in his unreasoning connoisseurship – taking curious pleasure in the quantity of paper'. It is interesting to note that the pencilled monogram seems not to have been intended, as in a modern etching, as a guarantee of authorship or originality, but rather signified that Whistler was responsible for the printing of the impression.

4 Nocturne, Palaces

1879–80 (*Second Venice Set*)
Etching and drypoint. 291 × 198 mm
1887-10-10-70. Presented by Messrs Dowdeswells and Thibaudeau
Kennedy 202, eighth state. Monogram on tab

The title relates this print to the series of Nocturnes painted by Whistler during the 1870s. The word however was not used of any etching before the Venetian series, where it occurs on no less than five plates (cf 10). The title's appropriateness to this print, where lines emerge from a film of ink, is obvious. The Pennells, in their biography of Whistler, assert that this is one of Whistler's poorest plates on the grounds that the ink merely covers up the rather weak lines of an indifferent design, and their view is more reasonable than the print's fame would suggest.

5 The Bridge

1879–80 (*Second Venice Set*)
Etching and drypoint. 295 × 198 mm
1887-10-10-73. Presented by Messrs Dowdeswells and Thibaudeau
Kennedy 204, eighth state. Monogram on tab

The bridge hanging above a foreground of rather indeterminate space is obviously influenced by Japanese prints.

6 The Balcony

1879–80 (*Second Venice Set*)
Etching and drypoint. 295 × 200 mm
1887-10-10-79. Presented by Messrs Dowdeswells and Thibaudeau
Kennedy 207, eighth state. Monogram on tab

The water in the foreground is defined by films of ink left on the plate. The etched lines depict only the reflections of the door and the mooring posts.

*7 The Garden

1880 (*Second Venice Set*)
Etching and drypoint. 302 × 235 mm
1887-10-10-82. Presented by Messrs Dowdeswells and Thibaudeau
Kennedy 210, eighth state. Monogram on tab

This is one of Whistler's most beautiful prints, and different impressions vary considerably in their inking. It is a classic example of his love of framing devices: the seated youth and the steps lead the eye through the wall into a garden at the back of which is a doorway framing another group of figures.

8 The Rialto

1880 (*Second Venice Set*)
Etching and drypoint. 297 × 203 mm
1929-12-14-10. Bequeathed by A. H. Studd, Esq.
Kennedy 211, second state. Monogram on tab

Arthur Studd (1863–1919), whose collection of twelve etchings and nineteen lithographs by Whistler was presented to the Museum by his executor with the wish that it be regarded as his bequest, was an interesting painter in his own right. In 1890 he worked with Gauguin in Brittany, and in 1898 visited him in the South Seas. He changed his style after meeting Whistler in 1894–5, and was his neighbour in Cheyne Walk. One of Whistler's lithographs of 1895 shows him and Miss Phillip. Studd directly bequeathed three very fine paintings by Whistler, including the *Little White Girl*, to the Tate Gallery.

9 Long Venice

1879–80 (*Second Venice Set*)
Etching with drypoint. 126 × 303 mm
1887-10-10-84. Presented by Messrs Dowdeswells and Thibaudeau
Kennedy 212, fifth state. Monogram on tab

The two domes of S. Maria della Salute have been added in drypoint. In the first state they were etched, but were burnished out and redrawn smaller in drypoint. The view was drawn directly onto the plate; thus in the printing it has come out reversed.

10 Nocturne, Furnaces

1879–80 (*Second Venice Set*)
Etching and drypoint. 169 × 229 mm
1887-10-10-85. Presented by Messrs Dowdeswells and Thibaudeau
Kennedy 213, seventh state. Monogram on tab

An extreme case of effect produced by inking. A heavy film of tone was left all over the plate, but has been wiped clean on the furnace itself and lightened on the window to the left.

11 La Salute: Dawn

1879–80 (*Second Venice Set*)
Etching. 126 × 201 mm
1887-10-10-87. Presented by Messrs Dowdeswells and Thibaudeau
Kennedy 215, fourth state. Monogram on tab

The view is more or less the same as that in 9 (*Long Venice*), and is also seen in reverse. A quite different atmospheric effect is produced by the use of a different paper and by leaving the sky empty.

*12 Fish-shop, Venice

1880
Etching and drypoint. 130 × 222 mm
1979-6-23-56. From the collection of G. W. Vanderbilt
Kennedy 218, second state (reproduced). Monogram on tab with 'imp'

This etching was not included in either of the published sets, almost certainly because the effect was spoiled in the later states. The range of tone and colour in this impression is extraordinarily wide, the deep lines of the foreground walls offsetting the light brown of the views into the passage and window, and the water in the foreground. This is achieved by exceptionally careful wiping.

*13 Pierrot

1889
Etching and drypoint. 230 × 158 mm
1929-12-14-12. Bequeathed by A. H. Studd, Esq.
Kennedy 407, fourth state. Monogram on tab

In 1889 Whistler made a wonderful series of fourteen etchings of Amsterdam, which is one of the great peaks in the history of etching. Astonishingly and most embarrassingly, this is the only one of the set in the Museum's collection, nor is it a particularly good impression. It shows, nevertheless, how in these late prints, Whistler again started hatching his shadows and foregrounds, using line and clean wiping again as he had in his earliest prints, rather than leaving ink on the plate in the wiping.

Joseph Pennell

1860–1926

Born in Philadelphia; his early, and much of his later work, was as an illustrator. Sent to Italy by a publisher in 1883, he spent much of his time until his final return to America in London. His abundant energy, irascibility and fluency in writing made him a very well-known figure, and he was closely involved in most of the printmaking societies and projects of the period. He first met Whistler in 1884, but only became a close friend in 1893, and henceforth acted as his foremost disciple, publicist and biographer (in conjunction with his wife, the writer Elizabeth Robins Pennell). Pennell's own etchings are very able developments from Whistler's later manner and show a new interest in urban and industrial subjects. After about 1910 he turned increasingly to transfer lithography (see 18) and made hundreds of very large, sketchy and monotonous prints. He was enormously prolific; the Library of Congress, to which he bequeathed his estate, has 1885 prints by him. His importance as the leading propagandist of the cause of printmaking in the United States outweighs his actual achievement.

Bibliography L. A. Wuerth, *Catalogue of the etchings of Joseph Pennell*, Boston, 1928; idem, *Catalogue of the lithographs of Joseph Pennell*, Boston, 1931; E. R. Pennell, *The life and letters of Joseph Pennell*, 2 vols, London, 1930.

14 St Paul building

1904
Etching. 301 × 213 mm
1913-1-17-1. Presented by Miss E. P. McGhee
Wuerth 334. Touched proof, signed and inscribed 'Model for printer'

So far as can be judged from the reproduction in Wuerth, this etching is in the completed state. The heavy black chalk shading must therefore be intended to guide the printer as to where to leave ink films on the plate when printing the main edition (of ninety). The name of the printer, Voight, is in fact written in the bottom left hand corner.

*15 From Cortlandt Street ferry

1908
Sandpaper aquatint. 329 × 252 mm
1949-4-11-4349. Bequeathed by Campbell Dodgson, Esq.
Wuerth 502. Signed with 'imp'

A view of the south-west corner of Manhattan Island across the Hudson River, showing the cluster of skyscrapers which already in 1908 dominated the financial districts.

*16 Mouth of the Rhine

1910
Etching. 237 × 316 mm
1949-4-11-4344. Bequeathed by Campbell Dodgson, Esq.
Wuerth 608. Signed with 'imp'

The trimmed margins and the tab left for the signature are devices borrowed from Whistler (cat. 3). The view is of Ruhrort, near Oberhausen.

*17 The New Rhine, Duisberg

1910
Etching. 241 × 317 mm
1949-4-11-4343. Bequeathed by Campbell Dodgson, Esq.
Wuerth 615. Signed with 'imp'

18 Liberty Tower

1910
Lithograph. 570 × 370 mm
1961-3-8-5. Presented by Miss Helen Barlow
Wuerth 185. Signed

This scene in New York is one of Pennell's best transfer lithographs (that is a drawing on special paper laid down onto a lithographic stone). The loss of definition in fact helps this image, but it is easy to sympathise with Walter Sickert when he called these prints mere reproductions. Pennell sued him for libel and won the case.

Bror Julius Olssen Nordfeldt

1878–1955

Born in Sweden; emigrated to America in 1891. He was trained in Chicago and made several voyages to Europe. He won several prizes during the first two decades of the century for his etchings and woodcuts. Later he moved to the south-west and seems to have dropped out of sight.

19 The New York Public Library

1910s (?)
Etching. 250 × 305 mm
1979-10-6-3. Signed with 'imp'

An interesting attempt to adopt Whistler's trick of a frame and interior with different textures of ink (cf. 7 and 12) to an American subject.

Donald Shaw MacLaughlan

1876–1938

Born in Charlottetown, Canada; his family soon moved to Boston and his early training was in Massachusetts. Went to Paris in 1898 where he took up etching in which he soon became a specialist. Almost all his plates are of views in Europe, where he spent most of his life. By the 1920s MacLaughlan had a considerable reputation, particularly in France where he was regarded as the greatest American etcher since Whistler. His work is now almost entirely forgotten, which is certainly unjust. He remains perhaps the best transatlantic representative of what may be described as the 'international' etching manner of the first decades of this century, basing his style particularly on the early work of Whistler and of Seymour Haden, and betraying little, if anything, that can be described as 'American'. He even inscribed his prints in French.

Bibliography A descriptive Catalogue of the Etched Work of D. S. MacLaughlan with an introduction by Marie Bruette, Chicago, 1924.

20 La Cité, Paris

1907
Etching. 298 × 296 mm
1949-4-11-4679. Bequeathed by Campbell Dodgson, Esq.
Bruette 98, second state. Inscribed: '2 *épreuves seulement.
D. S. Maclaughlan. La Cité. 2ème état*'

This and the following prints come from a group of sixty-two of MacLaughlan's etchings bequeathed by Campbell Dodgson. The large number reflects Dodgson's appreciation of his work.

21 The Lauterbrunnen

1908
Etching. 274 × 360 mm
1949-4-11-4680. Bequeathed by Campbell Dodgson, Esq.
Bruette 106. Signed and titled

A good example of the technique of conveying recession in space by biting to different depths. There is also a film of ink deliberately left on the mountain at the right hand side. This plate was one of the most praised of his oeuvre. In a letter describing its genesis, MacLaughlan said that he spent two entire days drawing the plate. It must have been this sort of information that induced critics like James Laver of the Victoria and Albert Museum to praise his 'sincerity of vision and honesty of draughtsmanship'.

22 Palazzo Vecchio, Florence

1909
Etching. 327 × 106 mm
1949-4-11-4683. Bequeathed by Campbell Dodgson, Esq.
Bruette 119. Signed

*23 The City of Towers

1909
Etching. 267 × 327 mm
1949-4-11-4691. Bequeathed by Campbell Dodgson, Esq.
Bruette 139, first state. Signed

A view of San Gimignano, near Florence. MacLaughlan was very fond of Italy, and lived in the years before the First World War in Asolo, in the hills north of Venice.

John Taylor Arms

1887–1953

Born in Washington; studied at the Massachusetts Institute of Technology as an architectural draughtsman. He took up etching in 1913, only becoming a professional artist in 1919. His great love was Gothic architecture and his earlier prints are of the great Gothic cathedrals in Europe. Most of his prints he gathered into sets of series on particular themes. His early plates are in the 'international' style (cf. MacLaughlan), but his technique became increasingly minute and exacting, and led eventually to the amazing *tours de force* of the 1930s and 1940s. These prints gained him, and have kept him, a group of enthusiastic admirers in Europe as well as America, but most will be repelled by their coldness and lack of atmosphere, and will conclude that he never managed to convey adequately his feelings towards the subject. He made 448 prints in all, of which eighty are in the British Museum's collection, but many are small and cannot have required the weeks of work of his largest plates. After Pennell's death, Arms seems to have taken on his role as the grand old man of American printmaking.

Bibliography S. W. Pelletier, 'J. T. Arms, an American mediaevalist', *The Georgia Review*, xxx, 1976, pp. 908–87.

24 The Gothic spirit

1922
Etching. 298 × 180 mm
1925-3-13-15. Presented by the artist
Signed and inscribed 'Artist's Proof'

One of the 'Gargoyle' series, and perhaps the most famous of his early plates.

*25 Gothic AD 1941 (East Liberty Church, Pittsburgh)

1941
Etching and aquatint. 394 × 455 mm
1960-4-9-647. Presented by David Strang, Esq.

This and the following print were presented by David Strang (son of the etcher William Strang), to whom Arms entrusted most of his plates for printing, regarding him as 'one of the great artist plate-printers of all time'.

26 U.S.S. Columbia under construction at New York Shipbuilding Corp. Camden, N.J. 1945

Etching. 313 × 440 mm
1960-4-9-649. Presented by David Strang, Esq.

Arms's records show that he spent 1352 hours on this plate, which implies that he worked from photographs. Apparently Arms could draw with both hands at once; if so, this plate would have taken an ordinary mortal twice as long. Between 1943–7 Arms was a civilian war artist, and made four such prints of U.S. Navy vessels, which were published in large editions for wide public sale.

Mary Cassatt

1845–1926

Born in a wealthy Pennsylvania family and studied at the Philadelphia Academy. Moved to Italy in 1868 and settled in Paris in 1874, where she became a friend and admirer of Degas and exhibited in the last four of the five Impressionist exhibitions. Despite living in France continually after 1874, she remained closely linked with her brothers and other American friends, and continued to lead the life of an expatriate. After 1899 her artistic output diminished and much of her time was devoted to

helping the Havemeyers and other friends build up their collections of modern French painting. Her numerous prints, mostly drypoints, were made between 1879 and 1911. Few were published in her lifetime and in consequence they are now rare. The Department possesses only the three prints exhibited here.

Bibliography A. D. Breeskin, *The graphic work of Mary Cassatt*, New York, 1948.

27 Gardner held by his mother

c. 1889
Drypoint. 211 × 137 mm
1949-4-11-4337. Bequeathed by Campbell Dodgson, Esq.
Breeskin 113

Cassatt's early prints are very experimental in character, often employing aquatint, and were done in close collaboration with Degas. Her best prints belong to the period between 1889 and 1899 and are in the main in pure drypoint. Gardner was her nephew, the son of her brother of the same name.

*28 The Bonnet

1891
Drypoint. 185 × 137 mm
1949-4-11-4336. Bequeathed by Campbell Dodgson, Esq.
Breeskin 137, third state. With the artist's stamp (Lugt 604)

One of a set of twelve drypoints shown in 1891 at an exhibition held jointly with Pissarro at Durand-Ruel's gallery in Paris. Their show was timed to coincide with the exhibition of the *Société des Peintres-Graveurs Français* from which they were both excluded by their non-French birth. Like the set of ten aquatints (see 29) these prints were published in an edition of twenty-five. The stamp 'MC' in blue ink found on this and other prints was put on by the artist to signify her approval of an individual impression.

29 The Coiffure

1891
Drypoint, soft-ground etching and aquatint, printed in colours from three plates. 365 × 263 mm
1949-4-11-4143. Bequeathed by Campbell Dodgson, Esq.
Breeskin 152, fourth state. Inscribed: '*Imprimé par l'artiste et M. Leroy. Mary Cassatt* (25 *épreuves*).' With the stamp of the artist (Lugt 604) and of F. E. Bliss (Lugt 265)

This is one of a set of ten colour aquatints made in 1891 for the same exhibition as 28 above, and published in an edition of twenty-five. The simplicity of the finished prints belies their technical complexity: the outlines were traced onto each plate and drawn in in drypoint, and then the aquatint was applied, in different areas on each of the three plates. Each plate was then inked in a different colour, some in more than one, for printing. Because this was a skilful and laborious job, Cassatt acknowledged the assistance of the printer Leroy. The immediate impetus for the prints was given by the 1890 exhibition of Japanese art at the *École des Beaux-Arts*, which she had visited together with Degas. As a result she purchased a group of woodcuts, mostly by Utamaro, and the subjects of her aquatints (women washing or with their children) echo Utamaro's. She wrote in a letter: 'The set was done with the intention of attempting an imitation of Japanese methods. Of course I abandoned that somewhat after the first plate and tried for more atmosphere'.

Julian Alden Weir

1852–1919

His father was instructor in drawing at the West Point Military Academy and had taught Whistler. Studied from 1873 in Paris under Gérome; later met Whistler and was influenced by Manet, three of whose paintings he purchased in 1881. In the 1890s his palette lightened under the influence of the Impressionists, and he was one of 'The Ten' who exhibited together in 1898. His 123 prints (mostly etchings and drypoints) were made between 1887 and 1892 when failing eyesight obliged him to give up. The main stylistic influence is probably Whistler (whose concern with the quality of paper Weir shared), but they are occasionally remarkably similar to Mary Cassatt. Unlike his close friend J. H. Twachtman, Weir often exhibited his prints and was the most important encourager of the art in America during the 1890s; his prints are probably also the best of the period. The forty-two prints by him in the Department were all presented by the artist in 1889 and 1890, or by his widow in 1925. Weir's letters show that he had a ticket to the British Museum Print Room when in London in 1877 and had looked at the prints by Whistler, Dürer and Rembrandt.

Bibliography A. Zimmermann, *An essay towards a catalogue raisonné of the etchings, drypoints and lithographs of Julian Alden Weir*, New York, 1923; D. W. Young, *The life and letters of J. Alden Weir*, New Haven, 1960.

30 The evening lamp

1887/9
Etching and drypoint. 156 × 117 mm (trimmed)
1889-9-25-20. Presented by the artist
Zimmermann 14, fourth state. Signed

31 Woman seated sewing

1889
Etching and drypoint. 129 × 93 mm (trimmed)
1890-4-16-14. Presented by the artist
Zimmermann 9

32 A judge of prints

1887/90
Etching. 125 × 90 mm (trimmed)
1890-4-16-5. Presented by the artist
Zimmermann 69. Signed

33 Standing figure

1889
Drypoint. 200 × 148 mm
1890-4-16-10. Presented by the artist
Zimmermann 15, first state. Signed

34 Boats at Peel, Isle of Man

1889
Etching. 246 × 195 mm (trimmed)
1889-9-25-16. Presented by the artist
Zimmermann 108, first state

This and the following print belong to a group of etchings made on the Isle of Man in 1889. Many show similar effects of grainy smudging, which were certainly deliberately caused by the artist.

*35 Fisherman's hut, Isle of Man

1889
Etching. 210 × 266 mm (trimmed)
1889-9-25-17. Presented by the artist
Zimmermann 116

A light grain, which has been stopped out in areas in the sky, has been applied over the whole plate.

Childe Hassam

1859–1935

Only took up etching in 1915 at the age of fifty-six, long after he had established himself as one of the leading painters in America. He was the moving force behind the exhibition of 'The Ten' in 1895, and was recognised as an American counterpart to the Impressionists in France. Between 1915 and his death he produced over 375 etchings and forty-five lithographs, which show his delight in the play of light and shadow. To convey this, he developed a manner of hatching of great originality and beauty. The two prints shown here do not give a complete idea of his work, but his many nude and figure studies are spoilt by poor draughtsmanship.

Bibliography Royal Cortissoz, *Catalogue of the Etchings and Drypoints of Childe Hassam*, New York, 1925.

36 Fifth Avenue, Noon

1916
Etching. 252 × 182 mm
1979-6-23-24
Cortissoz 77. Signed with monogram and 'imp' in pencil

The view, which is reversed in the print, shows the flags displayed on the 'Avenue of the Allies' as seen from a window on Thirty-fourth Street. Hassam made over thirty paintings of the scene. This etching shows Hassam's earlier style, in which the play of light is caught by short flickering lines.

*37 The Lion Gardiner House, Easthampton

1920
Etching. 251 × 356 mm
1979-4-7-7
Cortissoz 159. Signed in pencil with monogram and 'imp'

This print has always rightly been considered as Hassam's masterpiece. It shows to perfection his later manner where the heavily scribbled shadows and sudden patches of sunlight give a wonderful sense of atmosphere. It was clearly drawn on the spot, and one of his prints of this period is actually annotated with the time and the day. Lion Gardiner was the first English settler in New York State; Lion Gardiner Island, off Long Island, is still in the possession of his descendants.

John William Joseph Winkler

1894–1979

Born in Vienna; had arrived in San Francisco by 1906. He took up etching in 1912, and his best-known prints, made between then and 1922, are of the city and its various quarters, especially the Chinatown. Visited Europe from 1922 to 1930. His style is based on that of Whistler's *French* and *Thames* sets of 1858–61 and is marked by clean lines bitten to different depths. Winkler is an interesting example of an artist who found the right style for his preferred subject-matter – delapidated buildings and their inhabitants. It could scarcely have been used to portray New York, and in fact Winkler never adapted to the rebuilt San Francisco he found on his return from Europe in 1930.

38 Old Wharfs, San Francisco

1920
Etching. 243 × 177 mm
1979-11-10-8. Signed in the centre of the lower margin

A fine example of Winkler's work, showing the Whistlerian method of minutely detailing the centre of visual interest (the wharfs) while leaving the foreground and surrounds merely sketched in.

Maurice Sterne

1878–1957

Born in Russia; emigrated to America in 1889. A precocious youth of considerable promise, he held his first one-man show in 1902 and won a travelling scholarship to Europe in 1904. He returned in 1915, having abandoned his early Whistlerian manner, with a new style compounded of Gauguin and Cézanne and new subjects derived from a two-year stay in Bali. He also took up sculpture. In the 1920s his art became increasingly conservative. In 1933 he had a retrospective exhibition at the Museum of Modern Art and later decorated the library of the Department of Justice under the Treasury Relief Project.

*39 A scene on a beach

c. 1903
Etching. 214 × 304 mm
1949-4-11-4352. Bequeathed by Campbell Dodgson, Esq.

This print must belong to the set of etchings of Coney Island made during the earliest period of Sterne's career; he was appointed assistant instructor of etching at the National Academy of Design in 1903. It anticipates numerous later beach scenes of the Ash-Can school and the Coney Island views of Reginald Marsh, but is seen with a delicacy of perception much closer to Whistler or, indeed, Wilson Steer. It is surprising that Sterne's early etchings are now almost unknown as this is a print of remarkable achievement. This neglect is recent. In 1919 Max Friedländer, the brilliant director of the Berlin print room, was quoted as saying that only two Americans had appeared whose influence on art was of cosmopolitan importance: Whistler and Maurice Sterne.

John Sloan

1871–1951

Brought up in Philadelphia, and studied at the Academy of Fine Art there. His first job was as an illustrator on the staff of the *Philadelphia Enquirer*, but he maintained his interest in painting under the stimulus of Robert Henri. Was one of the leading members of 'The Eight' (the Ash-Can school) in their famous exhibition in 1908. He had moved to New York in 1904, and most of his work henceforth dealt with the life of the city. Around 1929, when his influence was at its greatest, his subject-matter shifted to nudes and landscapes and his art hardened. He also turned socialist and became art editor for *The New Masses*. His position as the most important of the first generation of painters of the American scene was always recognised, and his etchings of similar subjects (of which he made over 300 in the years between 1891 and 1940) were equally influential on the printmakers of the 1920s and 1930s. Bellows for example described him as 'the greatest living etcher and a very great artist'. This is not as exaggerated as it might seem, for the skill and artistry of his etchings is not apparent to a cursory glance.

Bibliography John Sloan, *Gist of Art*, New York, 1939; Peter Morse, *John Sloan's Prints*, New Haven, 1969; B. Saint John (ed.), *John Sloan's New York scene*, New York, 1965 (being the publication of his journal from 1906–13); Edward Hopper, 'John Sloan and the Philadelphians', *The Arts*, XI, April 1927, pp 168–78.

40 Connoisseurs of prints

1905
Etching. 126 × 175 mm
1965-12-11-4. Presented for Mrs Helen Farr Sloan by the
Wilmington Society of the Fine Arts
Morse 127. Signed and annotated 'Platt imp'

The first of a set of ten prints made between 1905 and
1906 of *New York City Life*. The subject of print con-
noisseurs had earlier appealed to Daumier. The Depart-
ment possesses twenty-nine of Sloan's prints which were
all presented in 1965 in the name of his widow.

41 Fifth Avenue critics

1905
Etching. 129 × 175 mm
1965-12-11-5. Presented for Mrs Helen Farr Sloan
Morse 128, tenth state, Signed and annotated 'Platt imp'

One of the *New York City Life* set. The women in the
carriage are portraits of two ladies who used to drive
up and down Fifth Avenue about four o'clock every
afternoon 'showing themselves and criticising others'.
This etching was later, in 1909, used to illustrate an
article by Walter Pach in the *Gazette des Beaux-Arts* on
some American painters. He compared Sloan to
Cruikshank and Leech.

*42 The woman's page

1905
Etching. 129 × 175 mm
1965-12-11-7. Presented for Mrs Helen Farr Sloan
Morse 132, first state. Signed and annotated 'J. S. imp'

One of the *New York City Life* set. Sloan regarded this a
one of his best prints, observing that it was 'done with
sympathy but no social consciousness'.

*43 Turning out the light

1905
Etching. 125 × 173 mm
1965-12-11-8. Presented for Mrs Helen Farr Sloan
Morse 134, third state. Signed and annotated 'Platt imp'

One of the *New York City Life* set. It is one of Sloan's
best and most famous prints.

44 Memory

1906
Etching. 182 × 218 mm
1965-12-11-11. Presented for Mrs Helen Farr Sloan
Morse 136, sixth state. Signed; annotated with the sitters'
initials and 'Ernest Roth imp'

The people depicted are (left) Robert and Linda Henri
with (right) Sloan and his wife Dolly. It was made as a
memorial after Linda Henri's death.

45 Roofs, summer night

1906
Etching. 132 × 174 mm
1965-12-11-9. Presented for Mrs Helen Farr Sloan
Morse 137, second state. Signed and annotated 'Peters
imp'

One of the *New York City Life* set. A typical scene in the
days before air-conditioning.

46 Anshutz on anatomy

1912
Etching. 188 × 226 mm
1965-12-11-15. Presented for Mrs Helen Farr Sloan
Morse 155, sixth state. Annotated 'J. S. imp 6th state
final'

Anshutz had taught anatomy to the students at the
Pennsylvania Academy of Art for nearly thirty years
before his death in 1912, and had been a close friend of
Thomas Eakins. This memorial print records a lecture
given in 1906 at Henri's School of Art in New York.
The figures in the audience are all portraits.

47 Arch conspirators

1917
Etching. 107 × 149 mm
1965-12-11-17. Presented for Mrs Helen Farr Sloan
Morse 183, second state. Signed and annotated 'Platt imp'

The print records a mid-winter party on the roof of the
Washington Square arch; the aim was to declare the
secession of Greenwich Village (an area in New York)
from the United States. The instigator was Gertrude S.
Drick, a poet; another participant was Marcel Duchamp,
the standing figure on the left.

*48 Hell hole

1917
Etching and aquatint. 200 × 250 mm
1965-12-11-16. Presented for Mrs Helen Farr Sloan
Morse 186, second state. Signed and annotated 'Ernest
Roth imp'

This print won the gold medal at the Sesquicentennial
International Exposition of 1926 at Philadelphia. The
scene is the rear room of Wallace's, a gathering place of
the bohemians and intelligentsia of Greenwich Village.
The man in the top right hand corner is Eugene O'Neill,
the playwright.

49 Snowstorm in the village

1925
Etching. 175 × 126 mm
1965-12-11-20. Presented for Mrs Helen Farr Sloan
Morse 216, third state. Signed and annotated 'Ernest Roth
imp'

A view of the elevated railway on Sixth Avenue as it
passed through Greenwich Village.

50 Kraushaar's

1926
Etching. 100 × 125 mm
1965-12-11-21. Presented for Mrs Helen Farr Sloan
Morse 229, eighth state. Signed and annotated 'Platt imp'

J. F. Kraushaar was a well-known picture dealer in
New York; he held various exhibitions of Sloan's work
and was a personal friend.

51 Indian detour

1927
Etching. 151 × 183 mm
1965-12-11-22. Presented for Mrs Helen Farr Sloan
Morse 231, third state. Signed and annotated 'Ernest Roth
imp'

*52 Nude reading

1928
Etching. 125 × 175 mm
1965-12-11-23. Presented for Mrs Helen Farr Sloan
Morse 234, fourth state. Signed and annotated 'Ernest
Roth imp'

The object in the background is an etching press.

53 Sunbathers on the roof

1941
Etching. 150 × 175 mm
1965-12-11-28. Presented for Mrs Helen Farr Sloan
Morse 307

A late reprise of themes of thirty years earlier. The plate
was commissioned by a very obscure 'American
College Society of Print Collectors'.

54 The wake on the ferry

1949
Etching. 126 × 177 mm
1965-12-11-29. Presented for Mrs Helen Farr Sloan
Morse 313, fourth state. Signed and annotated 'Ernest
Roth imp'

Sloan's last etching, made for the Art Students' League.
The idea for the subject – a drunken Irish wake – occur-
red to Sloan when someone suggested that he make a
print of a well-known painting he had done many years
earlier entitled *The wake on the ferry*, which showed the
sea foaming behind the stern of a boat, (now in the
Phillips collection, Washington).

George Bellows

1882–1925

Born and educated in Columbus, Ohio. Went to New
York in 1904, where he studied under Robert Henri,
who became a close friend and turned him to similar
subjects as those of the Ash-Can school. He quickly
became one of the best-known and most successful
American painters of his time, and his reputation has
continued to grow since his death. He only took up
lithography in 1916, and made 193 prints before his
early death from a ruptured appendix. All were
published by Bellows himself, and printed at his own
home with the aid of experts, first George Miller and
later Bolton Brown. They were drawn directly onto the
stone, and show a complete mastery of chalk and wash
techniques, astonishing at a period when the few
lithographs being made were weak derivations from
Whistler's lithotints. Many relate closely to paintings of
similar subjects, although the lithographs are often more
satisfactory as Bellows never showed similar assurance
in his handling of oil paint. The small group of prints
shown here represents only a limited (although the
most impressive) part of his range, for he also made
many portraits and studies from the nude.

Bibliography Lauris Mason, *The lithographs of George Bellows*, New York, 1977; C. H. Morgan, *George Bellows, painter of America*, New York, 1965.

*55 Solitude

1917
Lithograph. 435 × 393 mm
1979-5-12-5
Mason 37. Signed and annotated 'No 1'

The title shows a sense of humour typical of Bellows. It refers primarily to the single figure isolated under the lamp, but also ironically to the mass of lovers whose numbers prevent their finding any solitude whatever. Bellows identified the scene as Central Park, New York, on a spring night.

*56 A Stag at Sharkey's

1917
Lithograph. 477 × 611 mm
1979-10-8-91
Mason 46. Signed, titled and numbered 'No. 58'

This is Bellows' greatest lithograph, and the most famous American print of this century. It reproduces the composition of a painting of August 1909 (now in the Cleveland Museum of Art), but there are numerous differences which make the lithograph more concentrated and dramatic than the painting: the right hand side has been cut down, the numbers of spectators reduced and their positions clarified, and the foreground ropes made virtually invisible. Prize fighting at this time was illegal in America. To get round this, boxing matches were held in private clubs (of which Sharkey's Athletic Club in New York was one) on 'stag' evenings; the boxers had to be 'members' of the club. Bellows is reported to have said about one of his many paintings of fights: 'I don't know anything about boxing; I'm just painting two men trying to kill each other'.

*57 Dance in a madhouse

1917
Lithograph. 469 × 615 mm
1979-6-23-1
Mason 49. Signed 'Geo Bellows JBB' and annotated 'No 9'

Bellows wrote a long commentary on this lithograph: 'The artist as a young man was an intimate friend of the family of the superintendant of the great State Hospital at Columbus, Ohio. For years the amusement hall was a gloomy old brown vault where on Thursday nights the patients indulged in "Round Dances" interspersed with two-steps and waltzes by the visitors. Each of the characters in this print represents a definite individual. Happy Jack boasted of being able to crack hickory nuts with his gums. Joe Peachmyer was a constant borrower of a nickel or a chew. The gentleman in the center had succeeded with a number of perpetual motion machines. The lady in middle center assured the artist by looking at his palm that he was a direct descendant of Christ. This is the happier side of a vast world which a more considerate and wiser society could reduce to a not inconsiderable degree.' The drawing used for this print (in the same direction), which is in the Art Institute of Chicago, corresponds closely but far from exactly; it predates the lithograph by four years. The extraordinary Goyaesque power of the design is reinforced by the intensely cold black ink in which it is printed. The initials on this impression are of Bellows' daughter; these, or her mother's, were put on all the unsigned prints as they were sold from his estate.

*58 Business-men's bath

1923
Lithograph. 300 × 432 mm
1979-5-12-4
Mason 145. Signed by Bellows and the printer Bolton Brown

A revised and reversed version of a similar print made in 1917 (Mason 45). It is perhaps Bellows' most humorous print.

Max Weber

1881–1961

Born in Russia; his family emigrated to America in 1891. In 1905 he went to Paris, where he became a friend of Douanier Rousseau and a pupil of Matisse. Returning in 1909, he was one of those responsible for introducing recent French movements to the New York avant-garde. In 1913 he and Kandinsky were the only foreign artists invited by Roger Fry to exhibit with the Grafton Group (Bell, Grant, Lewis, Etchells) at the Alpine Club Gallery. His own work in this period shows a rather bewildering, although impressive, variety of styles, from Fauve to Cubist; his later work is figurative rather than abstract and is heavily indebted to Picasso. His best known prints are a group of about thirty small

woodcuts and linocuts, made in 1918. These are completely isolated attempts to adapt the methods of making woodcuts of Gauguin and the German Expressionists to a more direct borrowing of forms from primitive art. His interest in this can be seen in various articles published in Stieglitz's periodical *Camera Work* about the relevance of primitive cultures to modern sensibility.

Bibliography Whitney Museum of American Art, New York, *Max Weber Retrospective*, 1949.

*59 Reclining nude

1918
Woodcut. 44 × 133 mm (each impression)
1979-10-6-33

Two impressions from the same block have been printed above each other on a sheet of thin yellow Japan paper. They vary in inking and are clearly trial proofs printed by the artist himself. None of these prints seems to have been published in a regular edition. According to the Whitney catalogue, Weber made them using the sides of honey boxes, and printed them by pressing with his feet.

Edward Hopper

1882–1967

Born in Nyack, New York, in the same year as Bellows, and a fellow student in New York under Robert Henri, who greatly influenced him. Between 1906 and 1910 he made several journeys to Europe. These unsettled him: 'It seemed awfully crude and raw here when I got back. It took me ten years to get over Europe.' He first found his own style and subject-matter in the nearly seventy etchings and drypoints which he made between 1915 and 1923, after which he abandoned the medium in favour of painting and watercolour (excepting two drypoints made in 1928). His original and independent vision soon made him a well-known figure, and his position was established by a retrospective in the Museum of Modern Art in 1933. Since then his reputation has continued to grow, and he is now widely considered as one of the greatest American painters and undoubtedly the greatest American etcher of this century.

Bibliography Lloyd Goodrich, *Edward Hopper*, New York, 1971; Carl Zigrosser, 'The etchings of Edward Hopper', in *Prints* ed. C. Zigrosser, New York, 1962; Gail Levin, *Edward Hopper, the complete prints*, New York, 1979.

*60 Night on the El train

1918
Etching. 185 × 200 mm
1926-6-24-15. Presented by Campbell Dodgson, Esq.
Zigrosser 21. Signed

The four prints shown here are among the best that Hopper ever made. As mentioned in the introduction, they were all presented by Dodgson in 1926, a time when Hopper had already made a name for himself in America, but nevertheless astonishingly early in his career. Many bear the original prices marked in pencil, ranging from $18 to $22.

*61 Evening wind

1921
Etching. 175 × 210 mm
1926-6-24-14. Presented by Campbell Dodgson, Esq.
Zigrosser 9. Signed

Hopper began all the four etchings catalogued here by making drawings in charcoal in the same direction as the final print, which gave him the balance of light. This print was taken through eight states, areas being burnished out at two stages in the process. What was never touched was the absolute blankness of the window which is responsible for much of the air of menace.

*62 Night in the park

1921
Etching. 173 × 210 mm
1926-6-24-13. Presented by Campbell Dodgson, Esq.
Zigrosser 20. Signed

The comparison with Bellows' lithograph of the same subject (*Solitude*, cat. 55) is instructive. Bellows plays with the idea in an ironical manner; Hopper approaches it with deadly seriousness to a rather terrifying effect.

*63 East side interior

1922
Etching. 198 × 250 mm
1926-6-24-12. Presented by Campbell Dodgson, Esq.
Zigrosser 8. Signed

This print went through six states. The complete series of progress proofs at the Philadelphia Museum of Art shows how he built up tone by adding layer after layer of shading, or by burnishing it out. A wide area of shading around the framed picture was removed at an early stage. Only in the last state was the continuous

striated tone added to the back wall, which unifies the lighting of the interior of the room by comparison with the light seen through the window.

Martin Lewis

1882–1962

Born in Australia, but left home as soon as possible, arriving in America in 1900. He had little formal training as an artist, and his paintings and watercolours have never gained much attention. He took up print-making in 1915, and became one of the best-known American printmakers and a regular prize-winner in the 1920s and 1930s. His sales slumped seriously in the Depression, forcing him to sell his house, and he dropped completely out of fashion after the Second World War and more or less gave up etching. His 142 plates vary enormously in quality, and only a few dozen are really successful. These are all of New York, observed under different weather and lighting conditions; this distinguishes him from Hopper, who certainly in-fluenced him, and whom Lewis had in fact helped in his earliest efforts in etching. Lewis's phenomenal technical ability allied to his powerful vision and feeling for atmosphere put these prints among the very best of their period.

Bibliography No serious work about Lewis has ever been published. At present there are only two pamphlets published by Kennedy Galleries in 1973 that are of any value; one of them includes a checklist of his prints by Paul McCarron.

*64 Quarter of nine – Saturday's children

1929
Drypoint. 250 × 326 mm
1979-10-6-2
McCarron 88. Signed with 'imp'

The Saturday morning rush hour in New York, with the rays of light striking across the weird pseudo-Gothic architecture on the right. Much of the print's success is due to the brilliant stroke of setting a woman in silhouette on the left walking against the stream of pedestrians.

65 Snow on the El

c. 1929
Drypoint with sandpaper-ground aquatint. 353 × 228 mm
1979-10-6-1
McCarron 89. Signed

One of a small group of snow scenes. The sandpaper aquatint which Lewis often used is produced by pres-sing a sheet of sandpaper into an etching ground and then biting it. It produces a much coarser effect than an ordinary aquatint ground, an effect that Lewis found ideal for hazy, smoky or misty scenes.

*66 Spring night, Greenwich Village

1930
Drypoint. 252 × 314 mm
1979-4-7-11
McCarron 93. Signed

This print won the Charles M. Lea prize for the best print at the Philadelphia Print Club's eighth annual exhibition in 1931. The high angle of vision with its curiously impressive foreshortening was undoubtedly inspired by Hopper's etching, *Night shadows*, of 1921.

*67 Little penthouse

1931
Drypoint. 253 × 175 mm
1979-5-12-8
McCarron 101. Signed with 'imp' and dedicated 'To Warren Hutty, with best regards from his friend – M. L. May '31'

A particularly splendid impression, in which the dry-point is still printing with a strong burr. Lewis usually only used sandpaper aquatint for murky scenes. For night scenes like this, he used pure drypoint, scoring the plate with a thousand short scratches to raise the maximum amount of burr.

68 H'anted

1932
Drypoint with sandpaper-ground aquatint. 335 × 227 mm
1979-5-12-7
McCarron 104. Signed

*69 Day's end, Danbury

1937
Drypoint. 246 × 338 mm
1979-5-12-6
McCarron 129. Signed

Danbury is a town in Connecticut, about an hour's drive north of New York. Lewis lived just outside it between 1930 and 1936.

*70 Passing freight

1938
Drypoint with sandpaper-ground aquatint. 226 × 365 mm
1979-5-12-9
McCarron 133. Signed and with the stamp of Lucile Deming Lewis on the verso

One of Lewis's masterpieces, and a brilliant evocation of the hanging waterladen air of a very wet day.

*71 Shadow magic

1939
Drypoint. 341 × 239 mm
1979-5-12-10
McCarron 136. Signed and with the stamp of Patricia Lewis on the verso

72 Yorkville night

1948
Drypoint. 218 × 293 mm
1979-5-12-11
McCarron 141. Signed and annotated 'To my good friend and fellow denizen of Yorkville, Michael Lake: with all good wishes – March 10th '48'

Yorkville is an area of Manhattan Island around Eighty-sixth Street, between Second and Third Avenues, largely populated by German immigrants.

Mortimer Borne

Born 1902

Born in Rypin, Poland. Emigrated to America when young, and trained in New York. He took up print-making in the mid-1920s and has continued his activity into the 1970s. He is also a painter and a sculptor. In 1978 he presented eight drypoints made between

1929 and 1949 to the Museum, from which the items below have been selected. We are informed that they were all made on location directly onto the copper plate without any preliminary sketches.

73 New York from Weehawken

1929
Drypoint. 176 × 250 mm
1979-7-21-43. Signed with 'imp'

74 Negro preacher

1937
Drypoint. 252 × 177 mm
1979-7-21-44. Signed with 'imp'

*75 Rainy night

1939
Drypoint. 247 × 172 mm
1979-7-21-45. Signed with 'imp'

76 Broadway from Trans-Lux building

1939
Drypoint. 253 × 187 mm
1979-7-21-39. Signed with 'imp'

This impression has on the verso the stamp 'Federal Art Project NYC WPA' which was put on every print produced by artists employed on the Federal relief project (the Works Progress Administration). These works were the property of the State and were allocated to tax-supported institutions (offices, hospitals, etc.). Mr Borne informs us that because he did his own printing he was allowed to keep a few impressions himself.

Lawrence Kupferman

Born 1909

Born in Boston, working there most of his life. He retired as chairman of the Department of Painting of Massachusetts College of Art in 1969. In the 1930s, when employed by the Works Progress Administration, he made a series of etchings and drypoints, mostly of the facades of houses. His style changed completely in the 1940s, becoming first political and expressionist, and

later abstract expressionist. In very recent years, presumably as a result of the revival of interest in the 1930s, he has returned to making prints of buildings in his first manner.

*77 Victorian mansion

1938
Drypoint. 357 × 326 mm
1979-4-7-10. Signed, titled and dated 'Sept. 1938'

The artist has stated that his interest in buildings is largely in their expression as documents of human use and activity.

Charles Sheeler

1883–1965

Born and trained in Philadelphia. Made several visits to Europe in the early 1900s. In 1912 he took up photography, and became a distinguished photographer as well as one of the most highly regarded painters and draughtsmen of the period. He and Charles Demuth treated realistic subjects in a simplified way, with a Cubist-derived emphasis on geometric form. For this reason they are often known as 'Precisionists', although they never formed a school or issued any programme. Only five lithographs by him are known, made between 1918 and 1928. They are all drawn in crayon and are similar in feeling to his drawings.

Bibliography Charles Sheeler, National Collection of Fine Art, Washington, 1968.

*78 Delmonico building

1926 or 1927
Lithograph. 267 × 185 mm
1979-10-6-90. Signed, titled and numbered '#2'

The Delmonico building on Park Avenue and Fifty-ninth Street, was erected in the early years of this century. Sheeler's interest was not therefore in its modernity, but as a characteristic example of the simplified forms to be met in American life. For the same reason he was equally interested in Shaker interiors, still-lifes and industrial landscapes. In 1921 he had collaborated with another famous photographer, Paul Strand, in a film called *Mannahatta*, a portrait of the city concentrating on the perspectives of the canyons

between skyscrapers. In the early 1920s Sheeler took many individual photographs of skyscrapers, although there seems to be none directly related to this lithograph.

Louis Lozowick

1892–1973

Born in Kiev; emigrated to America in 1906. Although he had some training in America, his style was really formed by El Lissitsky and other Russian Constructivists whom he met when he lived in Berlin from 1920 to 1924; in 1922 he visited Moscow. Returning to America in 1925, he held an exhibition in adjacent rooms with Sheeler in 1926. In the late 1920s he became an editor of *The New Masses* and in the 1930s was well known for his political activity. Lozowick took up lithography in Berlin in 1923, and remains better known as a printmaker than as a painter, although he did two murals in the New York General Post Office. He made more than 270 lithographs during the course of his life, but their quality varies enormously, declining sharply in the 1930s, when his work became more social and realistic, reaching its nadir after the Second World War.

Bibliography Louis Lozowick, drawings and lithographs, National Collection of Fine Art, Washington, 1975.

*79 Still-life with guitar, no. 1

1929
Lithograph. 229 × 303 mm
1979-11-10-7. Signed, dated and titled

One of a small group of lithographs of still-lifes.

80 Tanks

1929
Lithograph. 355 × 203 mm
1979-11-10-4. Signed

In 1927 Lozowick wrote in the catalogue of the *Machine Age Exposition*: 'The dominant trend in America of today, beneath all the apparent chaos and confusion, is towards order and organisation which find their outward sign and symbol in the rigid geometry of the American city: in the verticals of its smokestacks, in the parallels of its factories, the arc of its bridges, the cylinders of its gas tanks.'

81 City on a rock

1931
Lithograph. 208 × 328 mm
1979-5-12-12. Signed

This print won the first prize of $1,000 at the exhibition of the Print Club of Cleveland in 1931. This was the biggest American print prize of the year.

Howard Cook

Born 1901

Born in Springfield, Massachusetts. After some years spent in tobacco farming and advertising, he trained as an artist in New York. He took up printmaking in 1925 and in the 1930s and 1940s produced very large numbers of etchings, drypoints and woodcuts. Their subjects are varied, often exotic, including many Mexican scenes, but his urban views are his most interesting works. The geometric simplification in the one print shown here is exceptional, and gives a misleading impression of the rest of his work.

82 Times Square section

1930
Drypoint. 304 × 250 mm
1979-6-23-25. Signed with 'imp' and numbered '4/75'

Stow Wengenroth

1906–78

Born in Brooklyn and trained in New York. Taking up lithography in 1931, he quickly achieved a remarkable mastery of lithographic chalk, creating a wider range of greys out of its various hardnesses than had been seen since the first half of the nineteenth century. His preferred subject, repeated in over 200 prints, was the coast of Maine and Massachusetts where he lived, and his success enabled him to earn a living in this way – the only specialist lithographer in the period that we have found. The print exhibited is exceptional as an urban view and is one of his earlier works. The viewpoint through balcony railings was used in several photographs by Berenice Abbott.

Bibliography R. & J. Stuckey, *Stow Wengenroth, complete lithographs 1931 to 1972*, Boston, 1974.

83 City street

1933
Lithograph. 318 × 246 mm
1979-5-12-14
Stuckey 36. Signed

Stuart Davis

1894–1964

Born in Philadelphia. In 1910 moved to study under Robert Henri in New York. Fundamentally affected by the Armory Show in 1913, he adopted a manner from Cubist collage. In 1928-9 he lived in Paris. His style at this time became markedly less abstract than it had been before, or than it was to be ever again in the future. In the 1930s Davis was perhaps the foremost avant-garde artist in America and was widely admired by other painters: Arshile Gorky, for example, in 1931, called him one of the 'giant painters of the century'. He was also prominent in artistic politics, being first secretary of the left-wing American Artists' Congress in 1936. Most of his twenty-two lithographs were made between 1928 and 1931, eleven in Paris and six in New York. For all their apparent abstraction, these prints all take the city as their subject-matter, and thus are surprisingly closely connected with the main line of American Scene printmaking of the period.

Bibliography Diane Kelder (ed.), *Stuart Davis*, New York, 1971.

*84 Two figures and El

1931
Lithograph. 281 × 381 mm
1979-11-10-2. Signed and annotated 'Artist's Proof'

One of the lithographs made after Davis's return to New York. Davis always stressed that he was not an abstract artist. His works, he said, were 'just compositions celebrating the resolution in art of stresses set up by some aspects of the American scene'.

Reginald Marsh

1898–1954

Born in Paris where his parents, both painters, were living. Brought up in a suburb of New York and went to Yale University. His first employment in 1920 was as a newspaper illustrator, and he only took up painting seriously in 1923. His first etchings were made in 1926, the year he fell under the influence of Kenneth Hayes Miller to whom he is said to have shown every painting he ever made. Most of his prints were based on paintings and show his fascination with striptease joints and the more sordid side of New York life. After the mid-1930s and even more after 1945 the quality of his work sharply declined; this change is marked in his prints by the adoption of engraving rather than etching. Marsh also made a few lithographs between 1928 and 1933, and a few woodcuts in 1921, which are important as proving his familiarity with the work of Dix and the German *Neue Sachlichkeit*. Marsh took many photographs which he used as raw material for his paintings. The prints shown here are all chosen from the portfolio of reprints of thirty of Marsh's best plates, published by the Whitney Museum (their owner) in 1969. Although considerably inferior to life-time impressions, they can still show the vitality of Marsh's work at its best.

Bibliography Norman Sasowsky, *The prints of Reginald Marsh*, New York, 1976; Lloyd Goodrich, *Reginald Marsh*, New York, 1972.

*85 Merry-go-round

1930
Etching. 172 × 249 mm
1979-10-6-36
Sasowsky 99

The innocuous scene has been changed into a grim pursuit.

86 Irving Place burlesque

1930
Etching. 247 × 300 mm
1979-10-6-37
Sasowsky 101

The audience, the real subject of this and all of Marsh's striptease scenes, is portrayed with a cynicism borrowed from Georg Grosz, but without his savagery.

*87 Gaiety burlesque

1930
Etching. 300 × 246 mm
1979-10-6-38
Sasowsky 102

88 Tenth Avenue at 27th Street

1931
Etching. 196 × 276 mm
1979-10-6-41
Sasowsky 128

89 Steeplechase

1932
Etching. 197 × 276 mm
1979-10-6-42
Sasowsky 138

90 Bread line – no one has starved

1932
Etching. 161 × 302 mm
1979-10-6-43
Sasowsky 139

The title reinforces the message of the image. A passage in Orozco's memoirs describes just such a scene: 'The municipality found itself obliged to open soup kitchens, and in the outlying districts there were frightening lines of powerful men queued up, hatless, in old clothes that offered little protection through hours of sub-zero weather as they stood in the frozen snow. Red-faced, hard, desperate, angry men, with opaque eyes and clenched fists.'

*91 Tattoo – Haircut – Shave

1932
Etching. 250 × 247 mm
1979-10-6-44
Sasowsky 140

Probably Marsh's finest print, presumably composed from photographs.

92 Star burlesque

1933
Etching. 300 × 223 mm
1979-10-6-45
Sasowsky 142

*93 Eerie railroad locos watering

1934
Etching. 222 × 300 mm
1979-10-6-47
Sasowsky 155

94 Steeplechase swings

1935
Etching. 222 × 326 mm
1979-10-6-48
Sasowsky 160

Peggy Bacon

Born 1895

Born in Connecticut; her parents were both artists. Between 1915 and 1920 she studied at the Art Students' League in New York under John Sloan and Kenneth Hayes Miller. Took up drypoint in 1917, the medium for which she remains best known. The earliest of these are reminiscent of contemporary French work, especially the prints of Jean-Emile Laboureur, but she soon developed an idiosyncratic satirical style which made her very popular in the 1920s and 1930s. After 1953 she abandoned printmaking and turned to painting, a medium she had not touched at all since her student days, although she had made many pastels. Much of her work has been in book illustration, often in books for children written by herself.

Bibliography Peggy Bacon, *Personalities and Places*, National Collection of Fine Art, Washington, 1975–6, (with a checklist of her prints by Janet Flint).

95 The spirit of rain

1936
Drypoint. 125 × 99 mm
1979-10-6-31
Flint 131. Signed and titled

Published in 1937 by Associated American Artists in an edition of 250. It is closely related to a pastel of the same year, one of a series of Manhattan subjects, showing people, places and objects of the lower East Side, where she has lived most of her adult life.

Isabel Bishop

Born 1902

Born in Ohio, moving to New York in 1918 and studying at the Art Students' League 1920-2. The main influence on her work here was Kenneth Hayes Miller; Reginald Marsh was a fellow-student and a close friend. She has always drawn her material from life on Union Square on Fourteenth Street, where she has a studio, and her work has been almost entirely restricted to the human figure, either individually or in small groups, where she has been concerned to capture the ambience created by class, setting, expression and movement. Her usual procedure is to start with a drawing, from which an etching or aquatint is made; only then does she make a painting of the subject. Isabel Bishop has recently become the focus of renewed attention and her work is much admired by artists such as R. B. Kitaj, who has in fact adapted 99 for his *Femme du peuple II* of 1975. The eight plates below, made at various times in her career, were printed and published together as a set in 1978; all are signed and numbered '5/50.'

Bibliography Tucson, Arizona, *Isabel Bishop*, 1974.

*96 Office girls

1938
Etching. 199 × 125 mm
1979-10-6-23

97 Lunch counter

1940
Etching. 186 × 99 mm
1979-10-6-24

98 Strap hangers

1940
Etching. 173 × 100 mm
1979-10-6-25

*99 Encounter

1941
Etching. 205 × 137 mm
1979-10-6-26

100 Ice cream cones, no. 1

1945
Etching. 188 × 102 mm
1979-10-6-27

101 Double date delayed

1948
Etching. 125 × 87 mm
1979-10-6-28

102 Outdoor soda fountain

1953
Etching. 158 × 106 mm
1979-10-6-29

103 Snack bar

1959
Etching. 173 × 113 mm
1979-10-6-30

Jose Clemente Orozco

1883–1949

With Rivera and Siqueiros, one of the group of Mexican artists who made their name in the 1920s when they were employed at labourers' wages by the Mexican revolutionary government to paint huge propagandist murals on public buildings. Orozco, unlike Rivera, had no training in Europe, and began life as a caricaturist. He became a well-known figure in the United States when he lived in New York in the period from 1927 to 1934. In 1931 he painted murals in the New School for Social Research in New York, and in 1932-4 another series in Dartmouth College. By the time of his death, Orozco was one of the most famous painters in the world, but he shared the obscurity of his fellows when the Mexican school fell precipitously out of fashion in the 1950s and 1960s.

Bibliography J. C. Orozco, *An Autobiography* (translated), Austin, 1962; Alma Reed, *Orozco*, New York, 1956.

*104 Note II (Manifestation)

September 1935
Lithograph. 335 × 425 mm
1979-6-23-23. Signed, dated, titled and numbered '31'

Orozco took up lithography in 1928 in New York. This print belongs to a series of eight made in 1935, after his return to Mexico. The title was supplied by Alma Reed, the artist's patron and dealer. The lithograph, one of his most powerful, shows regimented ranks of civilians marching under banners with slogans which are meaningless or simply state PROTESTA. Their leader is an outsized banner with legs. Unlike Rivera, Orozco was not a Marxist, and, although much of his painting is anti-clerical and concerns social injustice, this and other works show his distrust of mass movements.

Thomas Hart Benton

1889–1975

Born in Neosho, Missouri, to a prominent Democratic family. He ran away from home to become an artist. Between 1908 and 1911 in Paris. His experience in 1918-9 as a U.S. Navy draughtsman turned him decisively from his earlier avant-garde work towards portraying the American scene. After developing his mature style in 1926, he completed various mural cycles which established him as the leader of the so-called Regionalists. Benton made eighty lithographs, mostly between 1929 and the late 1940s. Most of them are closely related to paintings and drawings, and illustrate the people, landscape or songs of the American heartlands. Benton was always a highly controversial public figure. His admirers stressed his ability to convey the authentic multifariousness of American life, but this was often merely by means of a folksy baroque. His autobiography contains remarkable descriptions of his travels round rural America in the depths of the Depression.

Bibliography T. H. Benton, *An artist in America*, New York, 1937; Creekmore Fath, *The lithographs of T. H. Benton*, Austin, 1969.

*105 Strike

1933
Lithograph. 250 × 275 mm
1979-10-6-5
Fath 5. Signed

This print is unique in Benton's work in that it has a direct contemporary political relevance. It was published with prints by five other artists in a portfolio entitled *The American Scene* by the Contemporary

Print Group, founded in 1933. Its members included Marsh, Orozco, Grosz, Curry and others 'alive to contemporary social forces', and its programme stated that 'art can and should appeal to the general masses as well as to the cultivated few; that in seeking to make his work more socially significant the artist naturally seeks to enlarge his public'.

*106 The Race

1942
Lithograph. 227 × 333 mm
1979-11-10-6
Fath 56. Signed

The lithograph was made as a study for a painting entitled *Homeward Bound*. It is a particularly fine example of the romanticism which distinguishes Benton from the other Regionalists. He made a few notes of commentary on the image: 'Common enough scene in the days of the steam engine. Why did horses so often run with the steam trains while they now pay no attention to the diesels?'

Grant Wood

1892–1942

Born in Iowa, where he worked all his life, apart from several trips to Europe in the 1920s. When there, as he said, 'I realised that all the really good ideas I'd ever had came to me while I was milking a cow. So I went back to Iowa.' He leapt into national fame in 1930 when his painting *American Gothic* won a prize at an exhibition in Chicago. This and other paintings of these years give a splendidly satirical portrait of American provincial society, which was certainly influenced by Otto Dix. After about 1933, when he was labelled as one of the Provincialists, he took up landscapes, painted with the same curving plunging recessions as are seen, for example, in Paul Nash's work of the 1930s. His lithographs, which are unusual in the period for their light chalky textures, are mostly connected with these landscapes. The print shown here is exceptional in that it preserves the jaundiced insight of his best paintings of the early 1930s.

Bibliography James M. Dennis, *Grant Wood, a study in American art and culture*, New York, 1975.

*107 Shriner Quartet

1939
Lithograph. 203 × 303 mm
1979-10-6-64. Signed

The 'American Arabic Order of Nobles of the Mystic Shrine' was founded in America in 1872. It is not actually a Masonic order, but only thirty-second degree Masons, or Knights Templar, can belong to it. It claims to have been founded in Egypt in the seventh century, which explains why these four wear fezes and stand in front of a backcloth with pyramids, despite their western suits and ties.

John Steuart Curry

1897–1946

Born on a farm in Kansas; trained at the Art Institute there. He later went to Chicago and Paris. His painting of 1928, *Baptism in Kansas*, is a landmark in the development of the Regionalist school. Between 1919 and 1936 he was based in New York, but made summer excursions to the mid-West to gather material from the everyday life of the farm. In 1932 a tour with the Ringling Brothers' Circus led to a series of works on that theme. Curry took up lithography in 1927, and many of his prints are after his paintings.

Bibliography Sylvan Cole, Jr, *The lithographs of John Steuart Curry*, New York, 1976.

108 Stallion and Jack fighting

1943
Lithograph. 300 × 392 mm
1979-11-10-1
Cole 37. Signed

The print reproduces in reverse a painting of 1930.

Wanda Gag (Mrs Earle Humphreys)

1893–1946

Born in Minnesota, and trained there and at the Art Students' League in New York in 1917. Hardly known as a painter, she took up printmaking in 1926, making mostly wood-engravings and lithographs, which have a

pronounced Regionalist flavour. Her main work however was as a book illustrator; the books she wrote and illustrated for children – such as *Millions of Cats* – are said to be American classics. The twelve prints and single drawing by her in the Department were presented by Carl Zigrosser, the distinguished curator of the print collection at Philadelphia and a tireless advocate of the cause of American printmaking.

109 The forge

1932
Lithograph. 293 × 349 mm
1967-12-19-10. Presented by Carl Zigrosser, Esq.
Signed and dated.

The artist is quoted as saying: 'A still life is never still for me, it is solidified energy.'

110 Whodunit

Mid-1930s
Lithograph. 298 × 299 mm
1967-12-19-9. Presented by Carl Zigrosser, Esq.
With the blindstamp 'Cuno Phila. Pa. Impression' and stamp with artist's name

This is the only print in this catalogue that shows any influence from Surrealism, albeit of a rather bizarre kind which would scarcely have appealed to André Breton.

John Stockton De Martelly

Born 1903

Born in Philadelphia; studied at the Academy there and at the Royal College of Art in London. In the 1930s he lived in Kansas City, Missouri. He is primarily a painter, illustrator and cartoonist, and seems to have made few prints. The lithograph exhibited here is the best known of these, and shows the wide prevalence of Regionalist modes in the 1930s.

*111 Blue Valley fox hunt

Late 1930s
Lithograph. 325 × 418 mm
1949-4-11-4395. Bequeathed by Campbell Dodgson, Esq.
Signed

The inactivity of the hunters is explained by the difference from the English mode of fox-hunting. The sport in Missouri involves listening to the baying of the hounds, and laying bets as to which hound is in the lead.

Thomas Willoughby Nason

1889–1971

Born in New England and spent his childhood on a farm. His early career was in business; he took up wood-engraving as an amateur in 1922, only turning professional in 1931. Nason is now the best known of the specialist wood-engravers of the period in America, and his work compares interestingly with the much more abundant production of the same period in Europe.

Bibliography F. A. Comstock and W. D. Fletcher (ed. S. H. Hitchings), *The Work of Thomas W. Nason*, Boston, 1977.

112 Edge of the pasture

1935
Wood-engraving. 154 × 254 mm
1979-4-7-8
Comstock and Fletcher 186, second state. Signed, dated and numbered '30/50'

Asa Cheffetz

1896–1965

Born in Buffalo, New York, later living in Massachusetts. Cheffetz was a specialist wood-engraver, adopting the medium in 1928, and working in the same pastoral landscape vein as Nason and J. J. Lankes (not represented here unfortunately). These three seem to be the best American wood-engravers of the period, although there were many others making highly stylised figure compositions. The history of American wood-engraving in the 1930s remains totally obscure, and most of the printmakers concerned have been forgotten.

113 Border country

1930s
Wood-engraving. 113 × 230 mm
1979-10-6-4. Signed

Robert Riggs

1896–1970

Born in Illinois; after service in an Army medical unit in the First World War, he studied in Paris and New York before settling in Philadelphia. He worked in oil and watercolour as well as supplying commercial designs, but remains best known (though not as well as he deserves) for his remarkable lithographs, mostly made in the 1930s and early 1940s. Many of these are of boxing fights or circuses, and show an unblinking fascination for weird and unsettling subjects reminiscent of the photographer Diane Arbus. He is said to have been a large red-headed man with a penchant for lizards, snakes and turtles, of which he kept a large assortment in his rooms.

*114 On the ropes

c. 1934
Lithograph. 377 × 501 mm
1979-11-10-5. Signed, titled and numbered '24'

*115 Psychopathic ward

1941
Lithograph. 363 × 478 mm
1979-5-12-13. Signed, titled and numbered '5'

The lithograph is printed with a tannish-coloured tint stone, which gives a lurid tinge to the terrifying scene.

Willem De Kooning

Born 1904

A leading figure in the post-War New York School of painting, De Kooning exerted a considerable influence on his fellow artists. Although closely allied to Abstract Expressionism, his own work retained an important figurative element. He emigrated to the United States from Rotterdam in 1926 but was not able to become a full-time painter until 1935, after he had spent a year working on the Federal Art Project. In 1948 he joined Josef Albers at Black Mountain College and then at Yale, where he taught 1950-1. The year 1953 saw the completion of *Woman III*, the fundamental work of his career, which resumed a theme he had first embarked upon in 1938, after meeting his future wife, Elaine Fried. As with many of the Abstract Expressionists, De

Kooning's work as a printmaker has been very limited. He made his first print, a lithograph, in 1960, and made only two more and one etching before 1970-1, when he produced a group of twenty large lithographs on zinc and four smaller ones on stone.

Bibliography Thomas Hess, *Willem De Kooning*, Museum of Modern Art, 1968; Thomas Hess, *Willem De Kooning Drawings*, London, 1972.

*116 Minnie Mouse

1971
Lithograph. 698 × 532 mm (edge of stone irregular)
1979-10-6-14
Signed, dated and numbered '32/60'. Published by M. Knoedler & Co.

This is one of the group of four lithographs drawn on stone in 1971. As in much of De Kooning's work, the figurative element is fleetingly apparent through the agitated surface of the composition: the presence of Minnie Mouse is largely denoted by her distinctive shoes, which can be made out at the bottom of the print.

Jasper Johns

Born 1930

Worked as an artist for U.S. Army in Japan 1949-51. Moved in 1952 to New York where he partly supported himself by designing window displays until 1957, when he joined the Leo Castelli gallery. He established his basic artistic vocabulary with his first *Flag*, *Target* and *Number* paintings of 1954-5. His laconic use of real objects or their representations was akin to Rauschenberg's in its affinity to Dadaism. Johns, however, exploited these features with a painterly elegance quite alien to his contemporary's work. His first direct contact with Marcel Duchamp's work in 1959 coincided with the sculptures *Flashlight* and *Lightbulb*, Johns's most radical attempt to reduce the distinction between illusion and reality. In 1960 Universal Limited Art Editions published his first lithographs, and the choice of subjects illustrates the close dependence his prints have always had upon ideas previously developed in other media; *Target, Coat Hanger I & II, o through 9* (Victoria & Albert Museum, London) and *Flags I, II and III* all relate to earlier drawings. Initially his use of colour was largely confined to those prints which corresponded to paintings and he demonstrated as early as 1962 his ability to

handle a large number of colour combinations; *False Start I* of that year was printed in fifteen colours from eleven stones. His virtuosity has, however, been most apparent in the tonal variations he has wrought in black and white and grey lithography, using wash, crayon and scraping techniques and a relatively small number of stones or plates. Johns's *First Etchings* were executed in 1967-9 at the same time as his experiments in embossed printing and lead reliefs.

During the 1970s he has expanded his technical range to include offset lithography and screenprinting, continuing his recapitulation of earlier images, which has the effect of imparting a narrative element, largely absent from the original work.

Bibliography Max Kozloff, *Jasper Johns*, New York, 1969; Richard Field, *Jasper Johns: Prints 1960-70*, Philadelphia Museum of Art, 1970; Richard Field, *Jasper Johns: Prints 1970-77*, Wesleyan University, 1978.

*117 Gray Alphabets

1968
Lithograph printed from four aluminium plates.
1285 × 890 mm
1979-10-6-20
Field 114. Signed, dated and numbered '33/59'.
Published by Gemini G.E.L.

Gray Alphabets was printed during the seven weeks Jasper Johns spent in the Gemini lithography workshop, at the same time as his numeral series *Figures from 0 to 9*. The prototypes for its composition were a painting of 1956 and a drawing from 1960, both of the same title. Between 1956 and 1960 Johns produced several tabular compositions using numerals or letters as their denomination, the format having been derived from an alphabet chart in a book. *Gray Alphabets* of 1956 was executed in encaustic over newspaper, creating an illusion of depth which belies the intrinsic two dimensionality of the letters. The problems posed by the *Alphabets* are very similar to those characterising two comparable works of 1958, *White Numbers* and *Gray Numbers*: 'Are the numbers themselves the basic related elements, played off against the uniform tactile irregularity of the surface or is the studied, reiterative handling the actual source of interest, showing that the numbers are simply mute containers or buffers? . . . In the end, these pictures present themselves to the eye as diffident votive offerings, an elaborate braille.' (Kozloff, *op. cit.* p.19). *Gray Alphabets* of 1968 attempts to reproduce the effect of 'an elaborate braille' lithographically, through tonal gradations.

Robert Rauschenberg

Born 1925

Together with Jasper Johns, the leading member of the second generation of the New York School, famous for his unorthodox combinations of materials. His reputation was established in 1955 with *Bed*, a painting which incorporated a real quilt and pillow attached to the stretcher. In 1959-60 he made a series of drawings illustrating Dante's *Inferno* which introduced a new technique of transferring printed illustrations to paper by soaking the ink with lighter fuel and rubbing on the verso with pencil or ball-point. This led to a major change in 1962 when he made a series of black and white paintings by printing collages of images through silkscreens directly on to the canvas. At the same time he took up lithography at Universal Limited Art Editions, and these prints show the same 'iconography of divergent episodes and simultaneous events' composed of images culled from sports magazines, current affairs journals and fine art reproductions, allied with passages drawn directly on to the lithographic stone. Printmaking has in fact exercised a greater influence on his painting than that of any other major post-War American artist. By using the same screens in different contexts and arrangements he has managed to achieve some consistency in his imagery without any one theme dominating. In 1971 he opened his own print workshop, Untitled Press, in Florida, publishing lithographs by a number of artists, including Brice Marden. During the 1970s Rauschenberg's prints have become less uningratiating and have made more concessions to aesthetic appearances through the use of conspicuously elegant materials.

Bibliography Lawrence Alloway, *Rauschenberg Graphic Art*, University of Pennsylvania, 1970; *Robert Rauschenberg in black and white, paintings 1962-3, lithographs 1962-7*, Newport Harbour Art Museum, 1969; *Robert Rauschenberg*, National Collection of Fine Arts, Washington, 1976; Edward A. Foster, *Robert Rauschenberg: Prints 1948/1970*, Minneapolis Institute of Arts 1970.

*118 Spot

1964
Lithograph. 1044 × 756 mm (sheet size)
Signed, dated and numbered '26/37'. Published by
Universal Limited Art Editions

The kaleidoscopic imagery 'like the beginning of movietone news' (Lawrence Campbell in *Art News*, November 1963) which Rauschenberg introduced into his paintings of 1962 was adopted for the particularly impressive group of lithographs made between 1962 and 1965. Of these *License* of 1962 is in the Victoria and Albert Museum. *Spot* is closely related to two other prints of the same size made at the same time: *Kip-Up* and *Front-Roll*. All share the same use of plunging urban vistas, usually seen from above – a militaristic pilot's view which is emphasised in this print by the U.S. Army helicopter. The head repeated in the top right hand corner is the (reversed) reflection of the head of Venus in the mirror in Velasquez' *Rokeby Venus* in the National Gallery, London. The figure of Venus herself appears in a later lithograph of the same year entitled *Breakthrough*.

119 Subtotal

1970
Lithograph printed in three colours. 206 × 320 mm (sheet size)
1979-4-7-9
Signed, dated and numbered '202/500'. Published by Gemini G.E.L.

The rocket seen in this print can be traced back to the series of thirty lithographs Rauschenberg made in 1969 after he had been invited by NASA to watch the launching of the Apollo 2 moonshot (the *Stoned Moon* series). The image in *Spot* was transferred to the stone by silkscreen; in this case it was transferred by direct rubbing, the method he had previously used for the Dante drawings.

James Rosenquist

Born 1933

Brought up in the mid-West. Went to New York in 1955 on a scholarship to study at the Art Students' League. Crucial to the development of his particular 'Pop' style was his experience of commercial painting techniques. As a student he had worked during the summers painting gasoline tanks and grain elevators, as well as signs for the General Outdoor Advertising Company; later in 1957-60 in New York, he was employed as a billboard painter in Times Square for Artcraft Strauss Co. and turned his hand to window displays for department stores (like Johns and Warhol).

During the same period he met Johns, Rauschenberg, Robert Indiana and Claes Oldenburg, and in 1960 became a fulltime painter. Billboards had presented him with huge images to be painted at close range and this format exerted a powerful influence on his work. His most famous painting, *F-111*, of 1965, is eighty-six feet in length and shares many of the characteristics of a billboard. Unlike Johns and Rauschenberg, Rosenquist has no interest in collage or ready-made objects, and has preferred to work from enlarged photographs of magazine reproductions which are then translated into an impassive painterly rendering. His predilection has been for images of American life of the 1950s 'that people haven't started to look at yet, that have the least value of anything I could use and still be an image, because recent history seems unremembered and anonymous, while current events are bloody and passionate and older history is categorised and nostalgic.' His first lithographs were made in 1964-5 for Universal Limited Art Editions and the majority of his prints have been confined to this medium. In the late 1960s, however, he did make a number of screenprints, and more recently he has ventured into etching. The prints frequently reproduce the compositions of earlier paintings: the *F-111*, for example, appeared as a lithograph in 1974.

Bibliography Lucy Lippard, 'James Rosenquist, Aspects of a multiple art', in *Changing, Essays in Art Criticism*, New York, 1971; Marcia Tucker, *James Rosenquist*, Whitney Museum, 1972; *James Rosenquist Graphics Retrospective*, Ringling Museum of Art, Florida, 1979.

*120 Bunraku

1970
Lithograph. 810 × 592 mm (sheet size)
1979-10-6-18
Signed, titled, dated and numbered '32/60'. Published by Castelli Graphics

This print does not appear to correspond with any particular painting and the significance of the title remains obscure. 'Bunraku' is a form of puppet theatre peculiar to Japan; the puppets are distinguished by their size and prominent features and are manipulated by puppeteers who stand behind them dressed entirely in black. (We are indebted to Victor Harris of the Department of Oriental Antiquities for this information.) This esoteric reference may have been suggested to Rosenquist by his visit to Japan in 1966 or his course of studies of Eastern history and culture which he began in the summer of 1965 at the Aspen Institute of Human-

ist Studies, Colorado. An earlier lithograph of 1965-6, *Circles of Confusion I*, used the device of iridescent shapes floating through space, while a painting of 1970, *Flamingo Capsule* (repeated as a print in 1973), incorporates an area in which luminous balloons float against an unspecified ground; this latter composition offers the closest parallel to *Bunraku*.

Jim Dine

Born 1935

First made his name in various 'Happenings' in the late 1950s. In the 1960s worked in a variety of media, but since the early 1970s he has concentrated on print-making, and in this field has a reputation comparable to that of Johns and Rauschenberg. In 1976 he said: 'Making prints is as important to me now as making drawings or paintings.' His choice of subject-matter has been characterised as 'autobiography through objects', whereby he employs items of clothing, the paraphernalia of his studio or references to his family history (his father and grandfather were storekeepers who sold tools and supplies for painting and plumbing) as surrogates for human activity. This particular use of commonplace objects appeared in his first intaglio prints of 1961, a year later than his first lithographs, a series based on a *Car Crash* 'Happening'. Lithography and etching, and increasingly the latter, have remained his preferred printmaking techniques; although he has used screenprinting in combination with other techniques, he has otherwise avoided it, with the exception of the *Toolbox* series of 1966, which he later repudiated as mere reproductions. During 1967-71 he lived in London, experimenting with etching techniques at Petersburg Press, thereafter the major publisher of his work. From 1971 onwards he became increasingly interested in figurative art under the influence of R. B. Kitaj, beginning with a *Self-Portrait* series in 1971 and continuing to the erotic portrayals of 1976 (cat. 125). Dine prefers not to draw directly on to the plate, making instead meticulous preparatory drawings which are transferred photographically or by tracing. The image is often considerably reworked, surface tone is elaborately built up, and finally, in some cases, the plate is reworked altogether and used for a different composition.

Bibliography Jim Dine, Complete Graphics, Berlin, Galerie Mikro, 1970; *Jim Dine Prints, 1970–7*, Williams College Museum of Art, 1977; *Jim Dine*, Whitney Museum, New York, 1970.

*121 Self-portrait in zinc and acid

1964
Etching. 550 × 422 mm
1979-10-6-15
Mikro 25. Signed, titled, dated '1964 December' and dedicated 'Merry Xmas Judith love Jimmy'. Numbered '9/10'

This is Dine's first large-scale etching, his earlier prints being mainly lithographs. He had already introduced the notion of a self-portrait as suggested by various items of clothing in earlier paintings and prints; his adoption of a bathrobe in 1964 was apparently prompted by a magazine advertisement. It made a further appearance in 1965 and again in 1969, and thereafter became a recurrent image, charting Dine's increasing sophistication as a printmaker and his technical virtuosity in lithography, stencil, woodcut and etching.

122 Drag

1967
Photo-etching printed in colour. 866 × 1219 mm (sheet size)
1979-6-23-6
Mikro 44. Signed, titled, dated and numbered '28/53'. Published by Editions Alecto

The handling and subject of '*Drag*' make it Dine's most direct attempt to create a 'Pop' image in printmaking. Its size was unprecedented in his work at that time, and the impersonality of the technique remains unparalleled in his later prints. The subject developed out of the contemporary political situation. Dine chose two newspaper photographs of Chairman Mao and Lyndon Johnson, then the two most powerful men in the world. These were blown up (thus explaining the different type of dot) and individually photo-etched. As work developed Dine became fascinated by the contrast between the situations of the two men: Mao was at the height of his authority in the Cultural Revolution, while Johnson was on the wane under the stress of Vietnam. Their appearance as two queens in drag was made to reflect this difference. (This information has been kindly given us by Mr Studholme of Editions Alecto.)

*123 Braid, second state

1973
Etching printed in brown ink. 857 × 406 mm
1979-10-6-16
Williams College 149. Signed, dated and numbered '18/50'. Published by Petersburg Press

The first state of this plate was etched in 1972 and shows the braid set in a much wider space. After this had been published in an edition of forty-six, Dine cut down the plate on all four sides and reworked it. *Braid* illustrates the extent to which the etched line in Dine's work can be objectified almost independently of the subject of its delineation.

*124 Piranesi's 24 colored marks

1976
Etching with watercolour additions. 657 × 604 mm
Williams College 211. Signed, dated '1974–6' and numbered '25/30'. Published by Petersburg Press

The plate for this composition was first used in a print of 1973, *Wrench in Nature*, which showed the single wrench (to be seen also in the centre of this image) overprinted lithographically with four colours. Between 1974 and 1976 Dine produced three new prints from it, entitled *Dartmouth Still Life*, *Pink Chinese Scissors* and finally *Piranesi's 24 colored marks*. In each variant the forest of tools thickens. This print is a composite expression of Dine's 'autobiography through objects' with its references to the artist's own practice as a printmaker and the historical antecedents of that activity within the history of art and his own life. *Thirty Bones of my Body*, a series published in 1972, had previously articulated the same associations, each drypoint using a different tool as a metaphor for the 'bones'.

*125 A Nurse

1976
Etching with watercolour additions. 600 × 502 mm
1979-11-10-3
Williams College 201. Signed, dated and numbered '30/30'. Published by Pyramid Arts

This is one of eight prints published as a series *Eight Sheets from an Undefined Novel*; the other seven characters are: A Sufi Baker, Russian Poetess, The Swimmer, The Cellist, a Fancy Lady, Cher Maître and The Die-Maker. Half of these are nudes which show a kind of intense eroticism derived from Balthus. The series began with a group of drawings in coloured chalks made from store mannequins to which were added faces taken from photographs, friends, the artist himself (in the last two prints) and his wife. Dine chose eight of these to which he gave unrelated titles that appealed to him for their broad connotations. The drawings were photographed and reduced to a standard size of 610 × 510 mm. Tracings of the outlines were then redrawn on to a soft-ground plate which was lightly etched and then considerably reworked with a variety of tools. The plates were steelfaced before printing the edition of thirty. Dine deliberately used roofer's copper which is not highly polished; the ink it picks up in the wiping creates a rich background tone. (See the Williams College catalogue, pp. 31–2).

Robert Motherwell

Born 1915

The most literary figure among the post-War American artists, Motherwell rapidly established a reputation as a critic, editor and teacher. After studying philosophy at Stanford and Harvard Universities, he settled in New York in 1940; in the same year he painted *Little Spanish Prison*, his first reference to the Spanish Civil War, a theme which has preoccupied him throughout his career, finding its most notable expression in the *Elegy to the Spanish Republic* series begun in 1948. Motherwell became one of the main apologists for the Surrealist artists living in exile in New York, editing *The Dada Painters and Poets: An Anthology* in 1951. He was particularly attracted by their theory of automatism which has been reflected in his own work, principally the *Lyric Suite* of 1965, a series of 'automatic' drawings in ink on Japanese rice paper. Collage was also to play an important role in his work, influenced by French *papiers collés;* Motherwell's first experiments with this medium were carried out in conjunction with Jackson Pollock in 1943. During the 1940s Motherwell established close friendships with all the leading protagonists of Abstract Expressionism, collaborating with Clyfford Still, Barnett Newman and Mark Rothko among others to found 'The Subjects of The Artist' school, 1948–9. The *Elegy to the Spanish Republic* series, which continued into the 1960s, revealed Motherwell as a bold gestural painter on a grand scale, who, like Franz Kline, had a keen appreciation for the dramatic effect of black.

Motherwell's first experiments as a printmaker were conducted under the tutelage of Kurt Seligmann in 1941, and then in 1945 while he studied briefly with S. W. Hayter at Atelier 17's temporary workshop in New York. His first print of any consequence, however, was a lithograph *Poet I* (an impression is owned by the Tate Gallery, London), published by Universal Limited Art Editions in 1961. Lithography was an ideal medium for the translation of his painterly precepts at that time;

subsequently his collages, including those that incorporated Gauloises cigarette packets, were also rendered by lithographic means. During the late 1960s Motherwell turned from a gestural style to colour field painting, as exemplified by the *Open* series begun 1967–8; this was accompanied by a concomitant growth of interest in etching and aquatint, which permitted his use of a spare line against an area of densely saturated colour. More recently Motherwell has established his own printing facilities in Greenwich, Connecticut.

Bibliography Robert Motherwell, Museum of Modern Art, New York, 1965; *Robert Motherwell's 'A La Pintura'*. *The Genesis of a Book*, The Metropolitan Museum of Art New York, 1972; H. H. Arnason, *Robert Motherwell*, New York, 1977; Arthur Cohen ed., *Writings of Robert Motherwell*, Documents of Twentieth Century Art, New York, 1978.

126 A la Pintura

1972
A book containing twenty-four unbound pages with letterpress, etching and colour aquatint
648 × 965 mm (sheet size of each page)
1979-10-6-95(1 to 24)
Signed on the colophon page, dedicated 'For John McKendry with esteem, thanks and affection' and numbered 'VI/VIII'. Published by Universal Limited Art Editions

A la Pintura was published in an edition of forty with two printer's proofs and eight artist's proofs, of which the above copy is number VI. Three of the twenty-four pages are printed in letterpress only: the title page, the table of contents and the colophon. The remaining twenty-one are printed in a combination of aquatint, etching and letterpress, with the English translation alternating with the original Spanish text. Motherwell embarked upon his ambitious sequence of images in 1968, after finding a translation of the cycle of poems by the contemporary Spanish poet, Rafael Alberti, written in homage to the art of painting. The entire project, which took over four years to complete, is described in great detail in the booklet published to accompany the exhibition of *A la Pintura* organised at the Metropolitan Museum of Art, New York in 1972, under the auspices of the late Curator of Prints, John McKendry, to whom the British Museum's copy originally belonged.

Motherwell's choice of colours, both for the text and the pictorial images, corresponds to or complements those evoked by the poem. *Black 1–3*, the first page after the opening invocation 'To the Palette', is composed of a line plate printed in black against an aquatint ground of yellow ochre; one of the accompanying verses describes 'ink blacks; the bounding/black line that embodies our images/and bites in the dark with the burin'. In *Blue 6–11* Motherwell responds to 'The Venice of Titian: a blueness gone gold' and 'The phosphors and alcohol blues of El Greco' with a line plate printed in chrome yellow against two aquatint colours of pale blue and wine purple. Aquatint enabled Motherwell to achieve the required density of colour; the inking of the plate itself admitted a considerable range of tones; in *Red 4–7* the colour varies from velvet red to rose, once again reflecting the imagery of the poem which refers to 'Purples caught through cut glass-/goblet, decanter, and cup-/in the warmth of the wine', followed by 'The rose in the frost of Velasquez'. The line drawings, which provide 'openings' within the printed areas, were executed in sugar-lift aquatint with additional etched lines; their effect is analogous to that of his *Open* series of paintings, begun in 1967–8, which were conceived initially as line drawings in charcoal. The apertures created by these lines have been described as windows but the artist prefers to deny such a specific connotation, referring his audience instead to the plethora of definitions attached to the word 'open' in the Random House dictionary.

Alberti's poetic imagery, its wealth of art historical allusion and evocations of a Mediterranean landscape, were the perfect vehicle for the adumbration of Motherwell's own visual themes. The concluding exultation *To the Paintbrush* harmonises with his commitment to a highly individual virtuosity. Instead of celebrating this image with an actual brushstroke, Motherwell has chosen the final result of the artist's labour, a colour field canvas with the dripping, irregular evidence of the paintbrush's activity visible along the bottom edge.

Roy Lichtenstein

Born 1923

Together with Andy Warhol and Claes Oldenburg, Lichtenstein has been largely responsible for defining the content of Pop art. He has always been primarily attached to 'a purely American mythology' even in his earliest work, in which the Coney Island Beach scenes and boxing matches reflected the influence of Reginald Marsh, his teacher at the Art Students' League in 1939. After a period of Abstract Expressionism in the late 1950s, Lichtenstein began in 1961–2 to eliminate all

painterly and spontaneous features from his style in response to a new vocabulary of subject-matter drawn from reproductions of commonplace objects and animated cartoon characters. The banal imagery of the comic strip from cartoon books like *Armed Forces at War* and *Teen Romance* became the hallmark of Lichtenstein's painting during the mid-1960s. In common with Warhol, whose work he first saw in 1961, Lichtenstein attempted to deny the artist's personality altogether by imitating the texture of commercial reproduction. He differed from him, however, in that he did not use photo-screenprinting for transferring the image to canvas but projected it from a slide on to the canvas or traced it from a stencil. The composition was built up with 'Ben Day' dots in primary colours, in order to create on a magnified scale the effect of commercial illustration. Printmaking in lithography and screenprinting were a natural corollary to Lichtenstein's approach to painting and the two activities have proceeded almost simultaneously throughout the last fifteen years; even the degree of autographic intervention by the artist has become roughly equivalent in both fields, since Lichtenstein now uses assistants to cut the stencils and pick out the dots for his paintings.

Bibliography John Coplans (ed.), *Roy Lichtenstein*, London, 1972.

*127 Brushstrokes

1967
Screenprint. 584 × 787 mm
1979-12-15-1
Signed and numbered '168/300'. Published by the Pasadena Museum, California

Between 1965 and 1967 Lichtenstein produced several paintings and two prints which took the brushstroke as their subject, caricaturing the hallmark of the Abstract Expressionists by the calculated technique of their execution. The artist made his intentions quite explicit in an interview in 1967: 'Although I had played with the idea before, it started with a comic book image of a mad artist crossing out, with a large brush stroke X, the face of a fiend that was haunting him. I did a painting of this. The painting included the brush stroke X, the brush, and the artist's hand. Then I went on to do paintings of brush strokes alone. I was very interested in characterising or caricaturing a brush stroke. The very nature of a brush stroke is anathema to outlining and filling in as used in cartoons. So I developed a form for it which is what I am trying to do in the explosions, airplanes and people – that is, to get a standardised

thing – a stamp or image. The brush stroke was particularly difficult. I got the idea very early because of the Mondrian and Picasso paintings which inevitably led to the idea of a De Kooning. The brush strokes obviously refer to Abstract Expressionism.' (Coplans, *op. cit.*, pp.88–9). De Kooning's lithograph of 1960, *Untitled*, which took as its subject an artist's dramatic brushstroke, was precisely the kind of Abstract Expressionist source referred to by Lichtenstein.

Ed Ruscha
Born 1937

Moved from Oklahoma to Los Angeles in 1956 where he attended the Chouinard Art Institute, studying graphic and industrial design. He rapidly identified with the commercial culture of Los Angeles, particularly as exemplified in its neon signs. *Large Trademark with Eight Spotlights* was the first painting in which Ruscha used the letters of the sign as the objective content of the composition. He also embarked upon his career as a publisher in 1962, producing his first print *Gas*, a lithograph, and a book of photographs entitled *Twenty-six Gasoline Stations*. He continued the photographic recording of various categories of Los Angeles features in books like *Every Building on the Sunset Strip*, 1966, *34 Parking Lots*, 1967, and *Nine Swimming Pools*, 1968. Similar interests appear in his choice of subject matter for his paintings and prints: a screenprint of 1968, *Hollywood*, focuses on the illuminated sign on the hills above the city, while a lithograph of 1970 suggests illusionistically the presence of a book bearing the title *Some Los Angeles Appartments*, a counterpart to an actual book published by Ruscha in that year, *Real Estate Opportunities*. During 1965–72 he worked for the magazine *Artforum* doing layouts under the pseudonym 'Eddie Russia'. In this period his role as a printmaker and publisher largely superseded that of painter. He became increasingly involved in developing the expressive content of words, isolating them against a variety of fields, eliminating other descriptive features and concentrating on the letters themselves, the way they were drawn and their relationship to the space around them.

Bibliography Edward Ruscha, young artist, Minneapolis Institute of Art, 1972; *Edward Ruscha*, Albright-Knox Gallery, Buffalo, 1976.

*128 News, Mews, Pews, Brews, Stews, and Dues

1970
Screenprints. Each 578 × 813 mm (sheet size)
1979-6-23-15 (1 to 6)
Each signed, dated and numbered '71/125'. Published by Editions Alecto

The six prints in the portfolio were printed in 'organic' colours created by an unorthodox combination of food juices. The full list, complete with the names and addresses of the suppliers, is given in an accompanying leaflet:
NEWS Blackcurrant pie filling over red salmon roe
MEWS Bolognese sauce, blackcurrant pie filling over cherry pie filling over unmixed raw egg
PEWS Chocolate flavour syrup, Camp coffee, chicory essence and squid in ink
BREWS Axle grease over caviar
STEWS Baked beans, caviar, strawberries, cherry pie filling, mango chutney, tomato paste, daffodils, tulips and leaves
DUES Branston pickle
The portfolio is one of the most amusing and bizarre products of the printmaking euphoria of the time, but does in fact develop logically from Ruscha's earlier work. A screenprint of 1969, *Anchovy*, had matched the meaning of the word by the texture in which it was drawn. In 1970 Ruscha worked on an environmental room covered with chocolate-surfaced paper for the Venice Biennale. After his return to painting he continued to explore the properties of certain organic media: *Local Storms* of 1973 was executed in egg white on satin, and was followed in 1974 by *Laced*, spinach on paper, and *Good Reading*, beef extract on moire. In these the references to food became sublimated in the materials used by the artist. In an interview printed in the accompanying leaflet, Ruscha described some of the complications in making the set: 'Carnations did not pull. The paste separated from the liquid – so carnations are out . . . Let's see what else . . . Certain brands of mustard turned to dust, and chicory syrup similarly. A cream was not very satisfactory because it left slimy deposit . . .' The fact that the set was made in London dictated the title: 'England's the only country that has 'mews', and it also sounds very English. It's awful you see just to say it; the full six words that is. It has a corny and irritating sound to it. Language gets into my work. Country gets into my work. The type style relates to England; it's an Old English type set.'

Bruce Nauman

Born 1941

Like Ed Ruscha, Nauman has drawn much of his inspiration from West Coast American culture. His work embraces a variety of media, although he seems to have made few paintings. As a student at the University of Wisconsin in 1960-4, he transferred from mathematics to studio art, completing his education at the University of California, Davis. His first one man exhibition was held in Los Angeles in 1966, and consisted of fibreglass sculptures. In 1968 his work was exhibited in New York at the Castelli Gallery; on this occasion it embraced body art, dance pieces, acoustical and performance corridors. At the same time he had received a grant for videotape projects and was also producing light pieces. Nauman's work exemplifies what has been described as the 'dematerialisation of the art object', and has maintained its diversity during the present decade. The few lithographs he has produced have an unexpectedly painterly quality which betrays the influence of Jasper Johns.

Bibliography Bruce Nauman, Los Angeles County Museum, 1972.

*129 Normal desires

1973
Lithograph. 618 × 890 mm (sheet size)
1979-10-6-22
Signed, dated and numbered '32/50'. Published by Cirrus Editions, Los Angeles

Johns had used words within the context of a larger image, but not as an isolated phenomenon. In this respect Nauman shares Ed Ruscha's preoccupation with words as self-sufficient subjects. He had previously used neon signs to purvey elliptical messages, and then in 1973 and 1975 he published a group of lithographs whose lapidary statements ranged from *Normal Desires* to *Clear Vision* and *Eat Death*.

Sol LeWitt

Born 1928

Has been described as 'Minimalism's grammarian' (Norbert Lynton in *Order and Experience*). He began as a painter, also working for a brief period between 1955 and 1956 in the graphic department of the office of the architect, I. M. Pei. The essential components of his style were first demonstrated in the form of modular sculptures, seen in his contribution to the 1966 exhibition, *Primary Structures*, at the Jewish Museum, New York. The basis of the sculptures was a simple system, such as a three-dimensional grid, which LeWitt then proceeded to transfer to work on a flat surface. His first serial drawings and monumental wall drawings appeared in 1968; together with his subsequent prints, they could admit a greater degree of linear complexity than the three-dimensional sculptures. Graphic media possessed the further advantage for LeWitt of enabling the artist to divorce himself from the actual means of execution; after the early drawings, he frequently eliminated his own active participation, supplying other draughtsmen with his instructions. 'LeWitt demonstrates the possibility of drawing as pure ratiocination .. control is not a matter of manual participation but rather of setting up a system within which the execution of his system can only produce a LeWitt.' (Lawrence Alloway, quoted in *Drawing Now*, Museum of Modern Art, 1976). He has been prolific as a printmaker; the intermediary role of the printer is similar to that of the draughtsmen to whom LeWitt consigns the realisation of his ideas.

Bibliography Sol LeWitt Prints, Sedelijk Museum, Amsterdam, 1975; *Sol LeWitt*, Museum of Modern Art, New York, 1978.

*130 Lines from corners, sides and the center to points on a grid

1977
Etching and aquatint. 882 × 884 mm
1979-10-6-11
Signed and numbered '7/25'. Published by Parasol Press

This work is an individual print and not part of any series, although it does relate to two portfolios printed in black and white and in colour, entitled *Lines from the sides, corners and center of the page to specific points*. The antecedents of this particular use of diagonal lines against a black ground are to be found among a group of white chalk drawings on black walls which was begun in 1975. One of these, *Lines from the center of the wall, four corners and four sides to points on a grid*, was installed for the Museum of Modern Art's *Drawing Now* exhibition in 1976. In the print, the aquatint ground supplies the required density of blackness, against which the etched line simulates the effect of the white chalk in the drawings; the spatial references of the thrusting diagonals are further enlarged by the absence of a plate-mark, which has been achieved by using a plate greater in size than the paper.

Robert Ryman

Born 1930

Began to paint in 1954 after moving to New York, but did not hold his first one man exhibition until 1967, when he emerged as possibly the most 'rejective' of all the Minimalist painters. His work resembles Albers in so far as the square has been his chosen vehicle of formal expression, but unlike Albers he is not interested in colour relationships. By the early 1960s he had eliminated all colour except white from his compositions, even dispensing with the stretcher on occasions in order to make the painting as flat as possible against the wall. In this way he focussed attention on the physical appearance of the paint texture and facture, which he varied from one work to the next. His first portfolio of prints, *Seven Aquatints*, was published in 1972; he had produced two lithographs in 1971, but found the tactile qualities of aquatint more conducive to the kind of surface he wished to achieve. Ryman has explained the extent to which he is involved in the process of making his prints: 'I do all the initial process myself, the actual making of the plates, decisions about how thick the ink should be, what the texture should look like, which paper to use, etc. The way the prints are signed, the location of the signature and edition numbers, the use of drystamps – all these things are important and part of the essential process of printmaking.' (Toronto exhibition catalogue, 1975).

Bibliography Diane Waldman, *Robert Ryman*, Guggenheim Museum, 1972; Naomi Spector, *Robert Ryman*, Whitechapel Art Gallery, 1977; Naomi Spector, 'Robert Ryman's Six Aquatints', *Print Collectors' Newsletter*, March/April 1977.

131 Six Aquatints

(a) 902 × 898 mm (sheet size)
(b) 945 × 934 mm „
(c) 911 × 905 mm „
(d) 899 × 902 mm „
(e) 896 × 888 mm „
(f) 986 × 997 mm „
1975
1979-10-6-10(1 to 6)
Each signed, dated and numbered '13/50'. Published by Parasol Press

Six Aquatints are perhaps the most famous and classic set of Minimalist prints. They adhere essentially to the formal concepts that Ryman had adumbrated in his enamelac paintings of 1970, the *General Series*. These were executed on raw cotton canvas of which a margin was left untouched on all four sides of the composition. Ryman's work is perhaps more intractable for the spectator than that of Robert Mangold, Brice Marden or Sol LeWitt, his fellow Minimalist printmakers, since the subtle variations in the density of his aquatint grain, the colour of the white or cream and the arrangement on the paper become the only recognisable content. One critic has attempted to express the difficulties presented by work of this nature: 'The experience of looking at and perceiving an 'empty' or 'colorless' surface usually progresses through boredom. The spectator may find the work dull, then impossibly dull; then surprisingly he breaks out on the other side of boredom into an area that can be called contemplation or simply aesthetic enjoyment, and the work becomes increasingly interesting.' (Lucy Lippard, *Changing . . .*, p.134.)

Brice Marden

Born 1938

Like Robert Mangold, studied at the Yale School of Art and Architecture, where he received his master's degree in 1963. From the beginning his work has been conceived in black, white and grey and has been based on vertical and horizontal divisions of the rectangle. At the Jasper Johns retrospective exhibition at the Jewish Museum in New York, where he was working as a guard, he was particularly impressed with Johns's concern for surface and colour, as seen in paintings like *Grey Numbers* of 1956, which were also based on a grid pattern. Always preoccupied with the textural quality of his paintings, Marden after this date began to dull the surface by mixing beeswax with oil. In 1966 he became

a general assistant to Robert Rauschenberg, who, in more recent years, has published a number of Marden's lithographs at his press in Florida. Like other Minimalists, Marden has found a combination of etching and aquatint sympathetic to his intentions, and has produced five portfolios of etchings for Parasol Press between 1971 and 1979: *Ten days*, *Five plates* (in the Tate Gallery), *Adriatics*, *Five threes* and *Tiles*.

Bibliography Diane Waldman, *Brice Marden*, Guggenheim Museum, 1975.

*132 Four untitled prints from the *Ten days portfolio*

(a) Black rectangles on white. 370 × 600 mm
(b) Three horizontal rectangles. 396 × 522 mm
(c) Grid with white shading on black field. 304 × 383 mm
(d) Two vertical rectangles. 600 × 370 mm
1971
Etching and aquatint
1979-10-6-6 to 9
Each signed, dated and numbered '4/30'. Published by Parasol Press

The *Ten days portfolio* contains eight black and white etchings. They share the same formal concepts as Marden's paintings, but the essential difference is created by the medium. For an image conceived in terms of black and white, etching and aquatint give a depth of tone that stands above the surface and provides particularly rich contrasts. The artist has remarked of the relationship between his prints and his other work: 'Etching is an adjunct to my work in drawing and painting. I like the physicality and immediacy of etching.'

Robert Mangold

Born 1937

Studied 1959–63 at the Yale University School of Art and Architecture, of which Josef Albers had formerly been the head. Mangold's work quickly established itself within the canon of Minimalist art. His early asymmetrical canvases were influenced by Frank Stella. In 1967–8 he worked on a series of monochromatic, semi-circular paintings into which vertical and diagonal dividing lines were introduced; these compositions were repeated in his first prints, a group of screenprints published by the Orion Press. His subsequent prints,

published by Parasol Press, have used sequences of beautiful colours in a combination of aquatint and soft-ground etching which achieve a particularly seductive effect, belying the spareness of the constituent elements. Like the early screenprints they are closely related to his paintings in which the compositional problems are first resolved. The *Seven Aquatints* of 1973 (Tate Gallery) is a series of variations on the theme of a distorted square within a circle, an idea with which Mangold had previously experimented in a painting and a group of eight drawings of the same year. His prints of 1975 and 1979 continue the exploration of the effects on the perceived shape of the picture plane as created by the conjunction of curved and straight lines. In the case of the most recent published work, *Three Aquatints*, the paper itself has been shaped, leaving an incomplete rectangle on which an arc is described.

Bibliography Robert Mangold, La Jolla Museum of Contemporary Art, California, 1974; *Robert Mangold*, Guggenheim Museum, New York, 1972; Lucy Lippard, 'Silent Art, Robert Mangold', in *Changing, Essays in Art Criticism*, New York, 1971.

133 Five Aquatints

1975
Colour aquatint and soft-ground etching printed in three colours. 227 × 227 mm
1979-10-6-12(1 to 5)
Each signed on the verso, lettered A to E and numbered '16/50'. Published by Parasol Press

Five Aquatints are concerned with the intersection of arcs and straight lines rather than the circumscription of one by the other. In *Seven Aquatints* the distortion of the lines created a spacial illusion analogous to the shaped canvas. In these prints, however, the precise regularity of the square is constantly impressed upon our perception of the image.

Richard Estes

Born 1936

Perhaps the most important of the American Photo-Realists. He studied at the Art Institute of Chicago in 1952–6 and acknowledges the early influence of the nineteenth-century Realist Thomas Eakins and of Edward Hopper. His debt to Hopper is particularly obvious in his paintings of 1965–7. By 1970 he had eliminated people and any trace of narrative from his compositions, which present a hard-edged vision of a depopulated urban landscape, and the subject of his work has invariably been New York. The paintings are based on photographs taken on Sunday when the streets are empty. Estes' final compositions are, however, built up entirely by hand and do not rely on any form of photographic transfer. His first portfolio of prints, *Urban Landscapes I*, was published in 1971; his only other prints are *Untitled* (*Qualicraft Shoes*) of 1975 (Tate Gallery) and *Urban Landscapes II* of 1979. They are all screenprints of unprecedented complexity, using between fifty and eighty screens each, and are conceived as compositions in their own right, quite independently of his paintings. Estes executes a scale maquette in gouache for the printer and often intervenes to assist with the cutting of the stencils at the final stage. His choice of screenprint follows from the exigencies of his style: 'It seemed to me that silkscreen was very clean – sharp lines and opaque inks. I could work in layers which is more or less the way I paint . . . You can get it perfect – you don't ever have to worry about a color or tone until you print it. Just mix the color you want and put it on. It's limiting in the sense that the line is cut out so it's pretty hard and sharp. That seemed to fit pretty well with most of what I'm doing with the paintings – the sharpness of the line.'

Bibliography Richard Estes, the Urban Landscape, Boston Museum of Fine Arts, 1978; John Arthur, 'The Urban Landscape in print', *Print Collectors' Newsletter*, January/February 1979.

*134 Untitled, 40c

1979 (*Urban Landscapes* II)
Screenprint. 504 × 336 mm
1979-10-6-21
Signed and numbered '45/100'. Published by Parasol Press

The complete portfolio contains eight prints. The shallow space of the composition, its rectilinearity and the play of the reflections in the plate-glass window are all characteristic of Estes' treatment of urban streets.

Technical Glossary

(For fuller explanations, see the forthcoming book by Antony Griffiths, *Prints and Printmaking: an introduction to the history and techniques*, to be published by the Trustees of the British Museum in mid-1980.)

Aquatint A variety of etching in which tone is created by fusing grains of rosin to the plate and etching it. The acid bites in pools around each grain; these hold sufficient ink to print a light grainy tone.

Drypoint A process similar to etching except that the line is not bitten into the plate by acid but directly scratched in with a sharp needle.

Etching A waxy ground is laid on a metal plate, through which the artist draws his design. The lines of exposed copper are then eaten away in an acid bath. After cleaning off the ground, the plate is inked so that the ink lies only in the bitten lines and the surface is wiped clean. The plate is printed by laying a sheet of paper over it and running both through a press under considerable pressure.

Lithography A method of printing from stone or zinc. It relies on the fact that grease repels water. The design is drawn on the surface in some greasy medium. This is printed from in the following way: the surface is dampened with water which only settles on the unmarked areas since it is repelled by the grease in the drawing. The surface is then rolled over with greasy printing ink, which only adheres to the drawing, the water repelling it from the rest of the surface. Finally the ink is transferred to a sheet of paper by running paper and the printing surface together through a scraper press.

Screenprint This is a variety of stencil printing. A mesh is attached to a frame and a design either drawn on it in some impermeable medium or a stencil is attached to it. Ink is forced through the screen onto a sheet of paper with a squeegee.

Soft-ground etching A variety of etching which uses a soft etching ground. By laying a sheet of paper on top of the grounded plate and drawing on the paper, the ground is made to adhere to the underneath of the paper. A precise facsimile of the drawing is thus left in the ground and can be etched into the plate in the usual way.

Wood-engraving Lines are incised into a block of very hard wood to create the design. Ink is then rolled over the surface of the block which is printed under light pressure onto a sheet of paper. The design stands out as white lines on a black ground.

Bibliography

General

Barbara Rose, *American Art since 1900*, London, 1967

Sam Hunter, *American Art of the 20th Century*, London, 1973

J. I. H. Baur, *Revolution and Tradition in modern American art*, Cambridge, 1951

The Modern Spirit, American Painting 1908–1935, Hayward Gallery (Arts Council), 1977 (by Milton W. Brown)

Milton W. Brown, *American Painting from the Armory Show to the Depression*, Princeton, 1955

Matthew Baigell, *The American Scene, Painting of the 1930s*, New York, 1974

New York Painting and Sculpture 1940–1970, Metropolitan Museum of Art, New York

Lawrence Alloway, *American Pop Art*, New York, 1974

Lucy R. Lippard, *Changing, Essays in Art Criticism*, New York, 1971

Printmaking

Riva Castleman, *Prints of the Twentieth Century, a history*, London, 1976

Karen F. Beall *et al.*, *American Prints in the Library of Congress*, Baltimore, 1970

American Prints 1913–1963, from the Museum of Modern Art, New York, Leeds (Arts Council), 1976

Thomas Craven, *A Treasury of American Prints*, New York, 1939

Timothy A. Riggs, 'Two decades of American printmaking', *Worcester Art Museum Bulletin*, February 1978

Contemporary Graphics from the Museum's Collection, Museum of Art, Rhode Island School of Design, 1973 (by Diana Johnson)

Recent American Etching, Davison Art Center, Wesleyan University, 1975 (by Richard S. Field)

Order and Experience, Arts Council, 1975 (by Norbert Lynton)

Prints: Bochner, LeWitt, Mangold, Marden, Martin, Renouf, Rockburne, Ryman, Art Gallery of Ontario, 1975–6

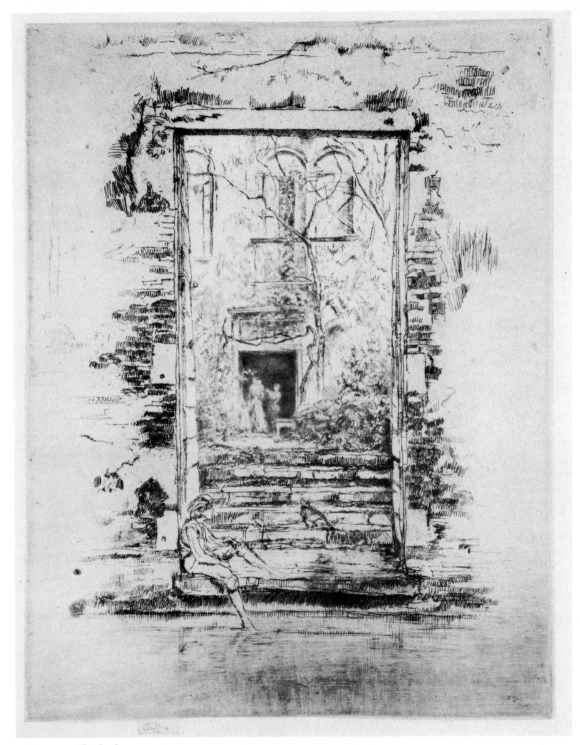

7. WHISTLER *The Garden*

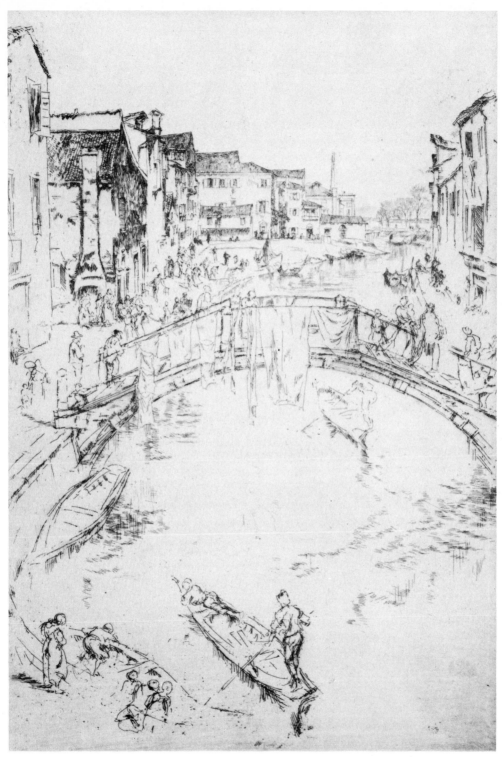

1. WHISTLER *San Biagio*

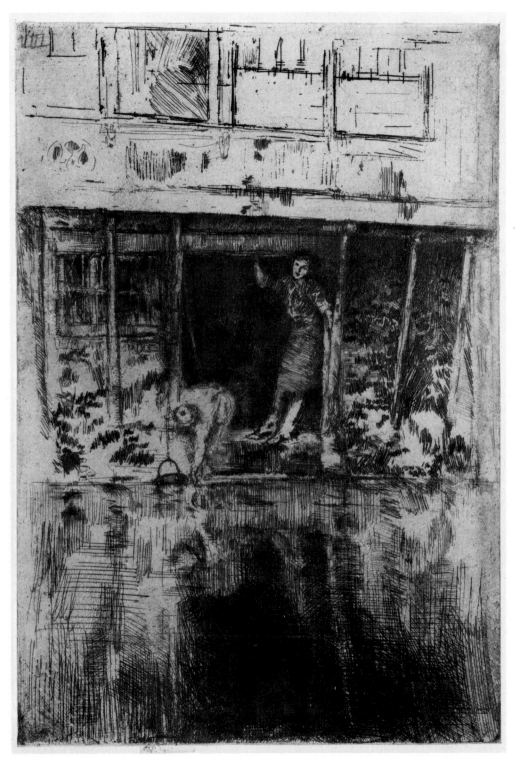

13. WHISTLER *Pierrot*

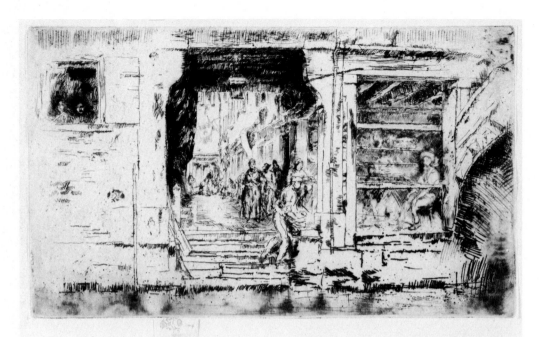

12. WHISTLER *Fish-shop, Venice*

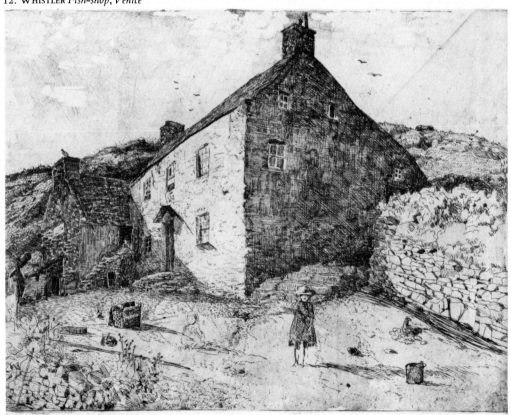

35. WEIR *Fisherman's hut, Isle of Man*

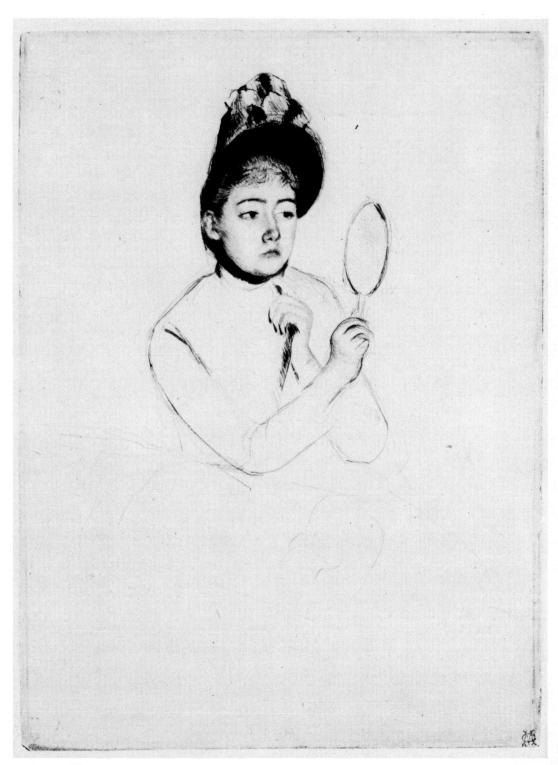

28. CASSATT *The Bonnet*

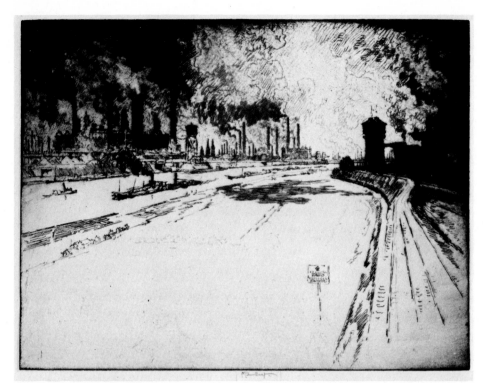

16. PENNELL *Mouth of the Rhine*

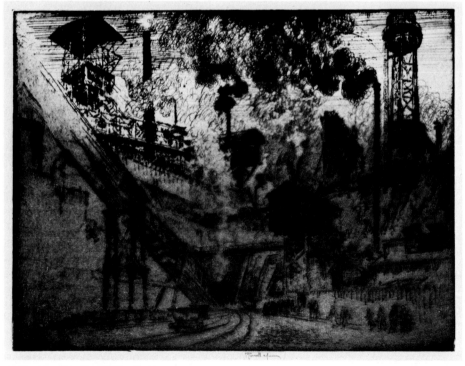

17. PENNELL *The New Rhine, Duisberg*

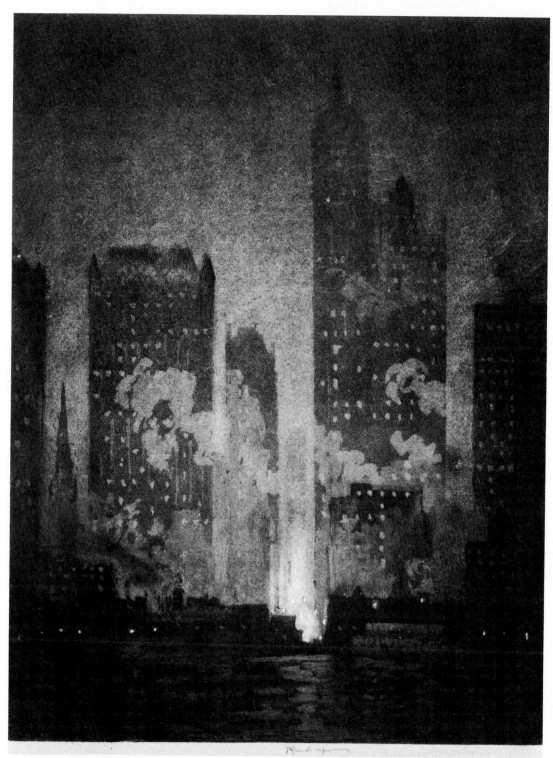

15. PENNELL *From Cortlandt Street ferry*

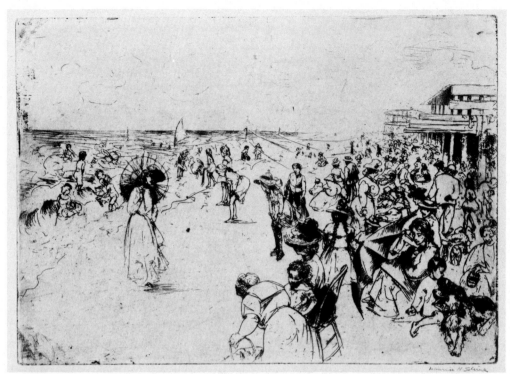

39. STERNE *A scene on a beach*

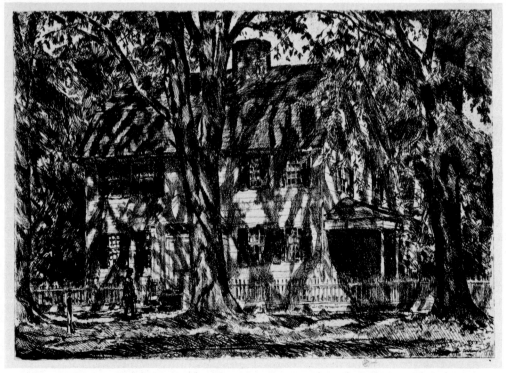

37. HASSAM *The Lion Gardiner House, Easthampton*

25. ARMS *Gothic AD* 1941 (*East Liberty Church, Pittsburgh*)

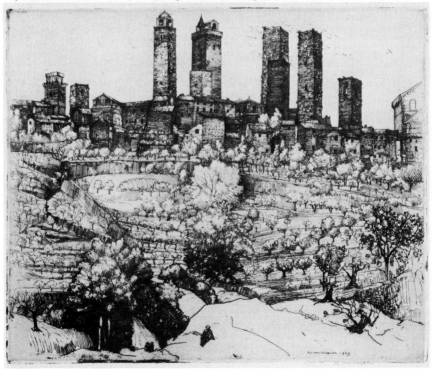

23. MACLAUGHLAN *The City of Towers*

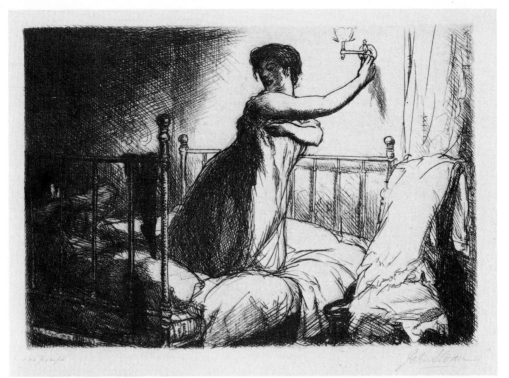

43. SLOAN *Turning out the light*

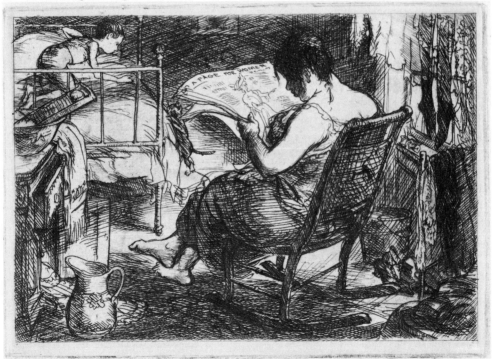

42. SLOAN *The woman's page*

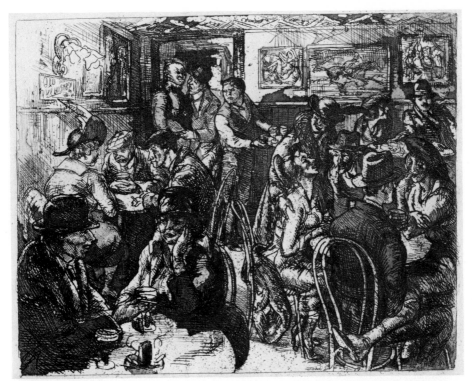

48. SLOAN *Hell hole*

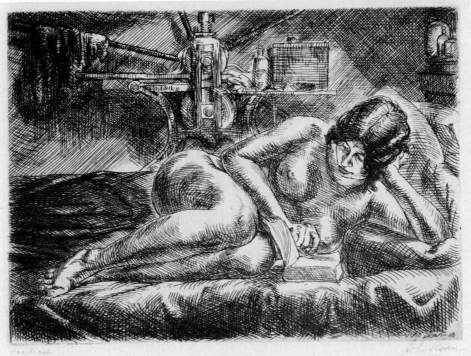

52. SLOAN *Nude reading*

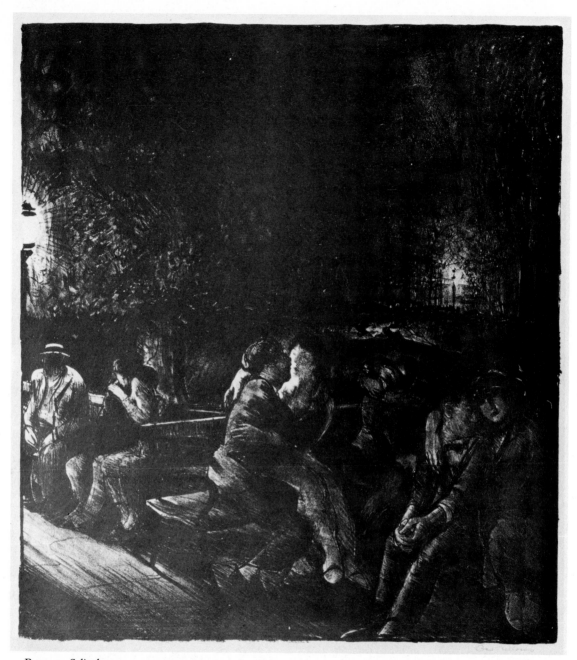

55. BELLOWS *Solitude*

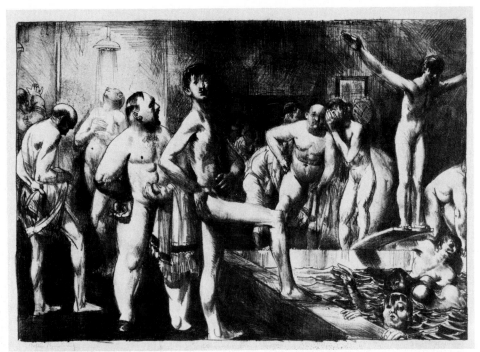

58. BELLOWS *Business-men's bath*

59. WEBER *Reclining nude*

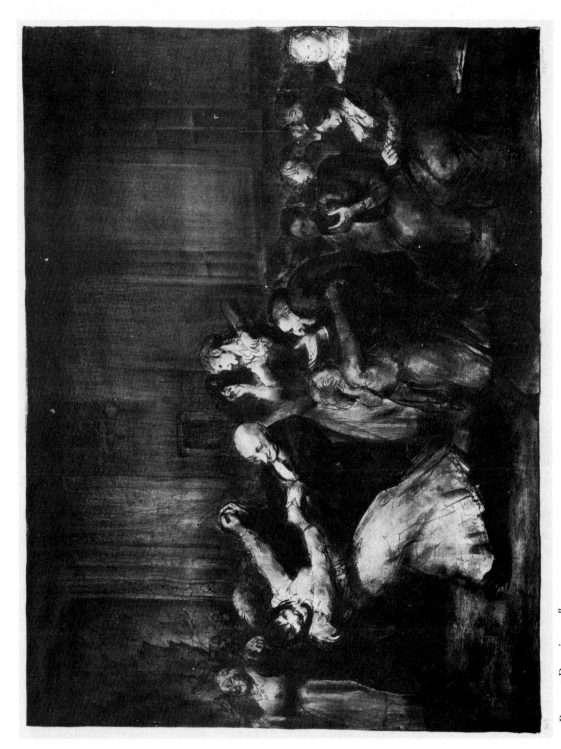

57. BELLOWS *Dance in a madhouse*

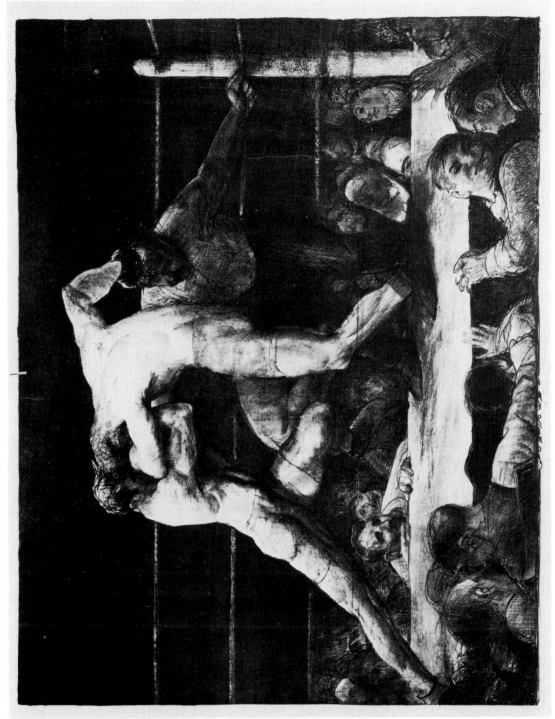

56. BELLOWS *A Stag at Sharkey's*

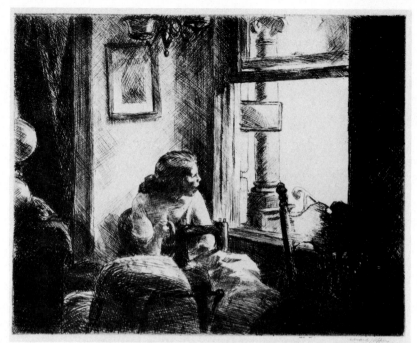

63. HOPPER *East side interior*

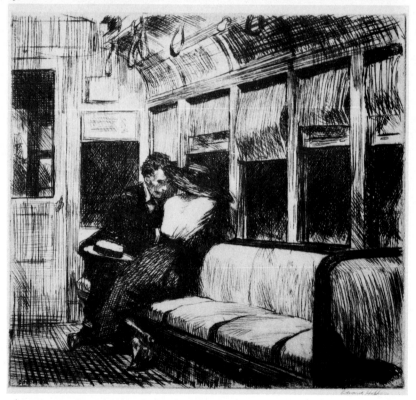

60. HOPPER *Night on the El train*

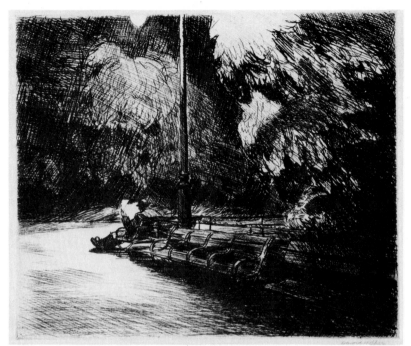

62. HOPPER *Night in the park*

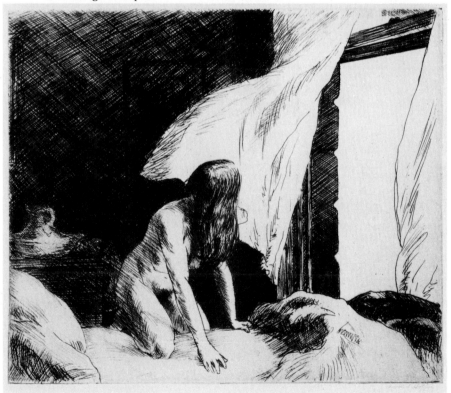

61. HOPPER *Evening wind*

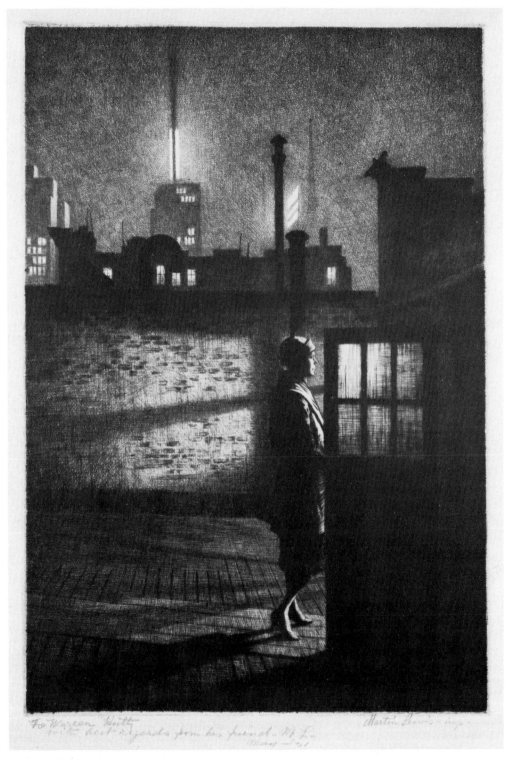

67. LEWIS *Little penthouse*

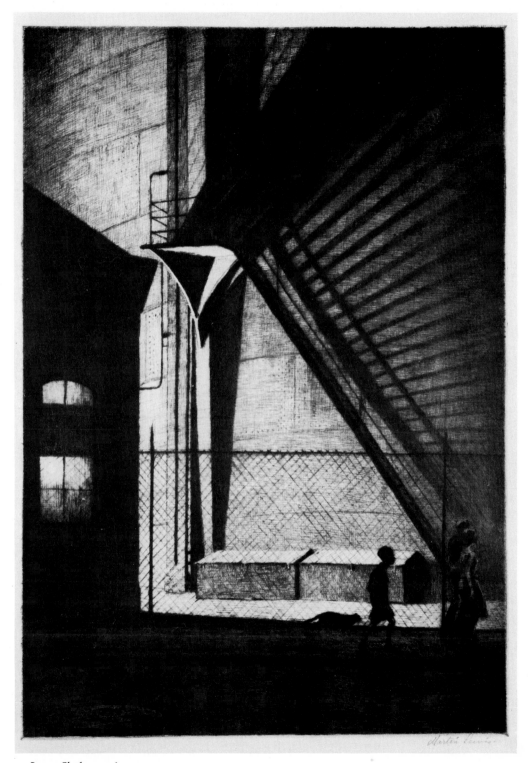

71. LEWIS *Shadow magic*

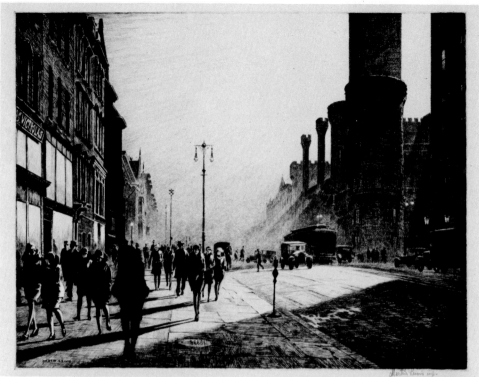

64. LEWIS *Quarter of nine – Saturday's children*

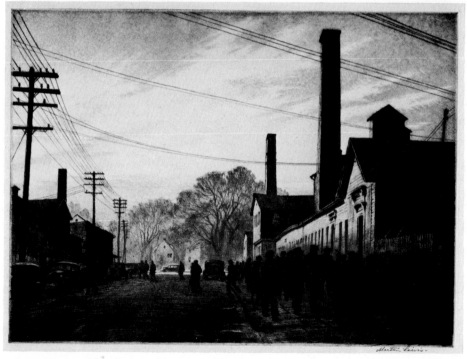

69. LEWIS *Day's end, Danbury*

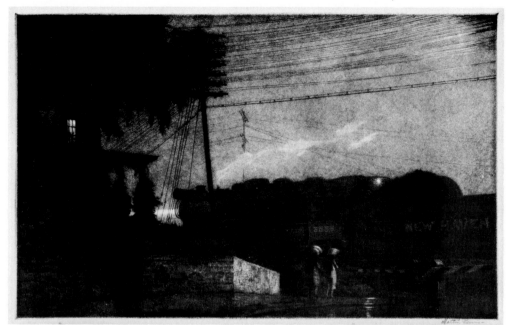

70. LEWIS *Passing freight*

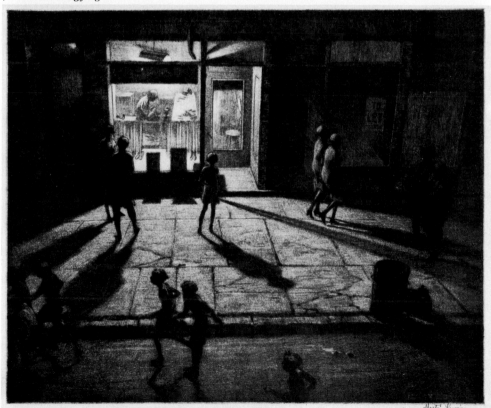

66. LEWIS *Spring night, Greenwich Village*

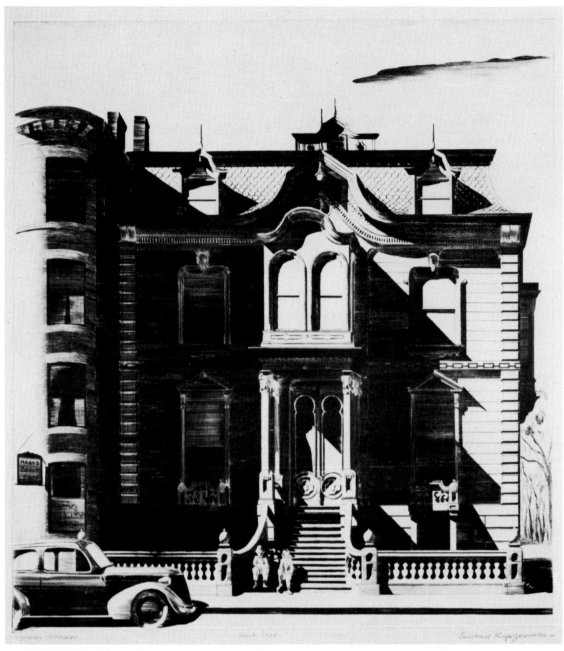

77. KUPFERMAN *Victorian mansion*

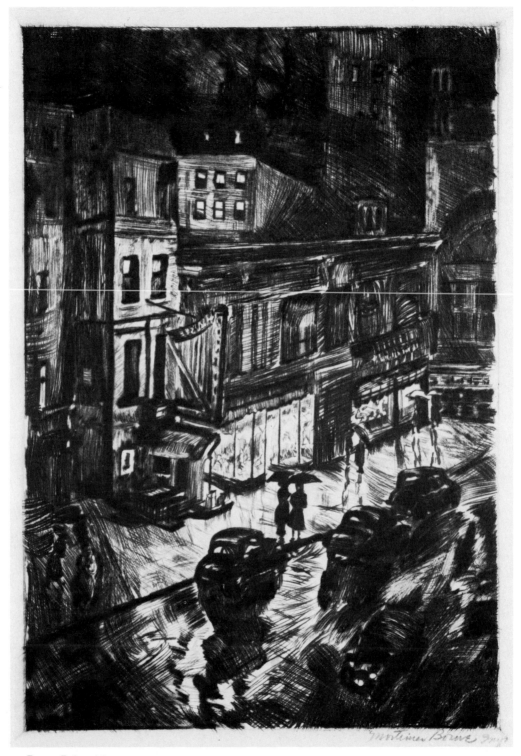

75. BORNE *Rainy night*

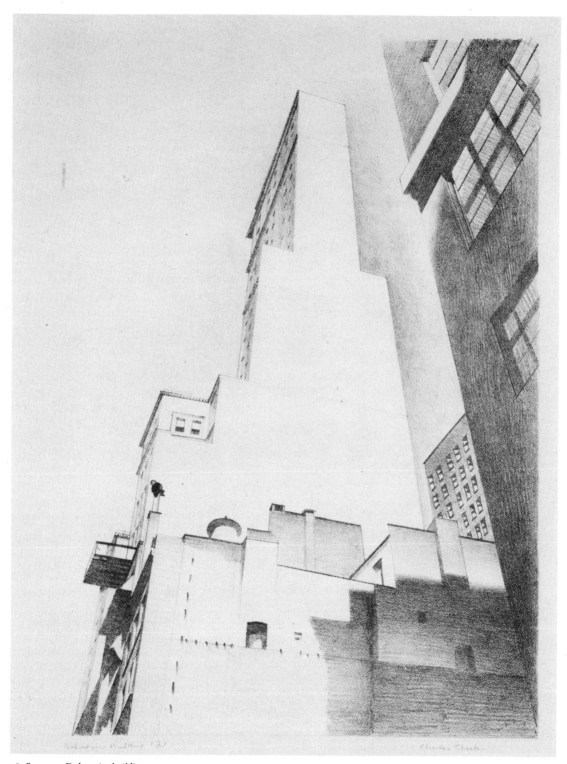

78. SHEELER *Delmonico building*

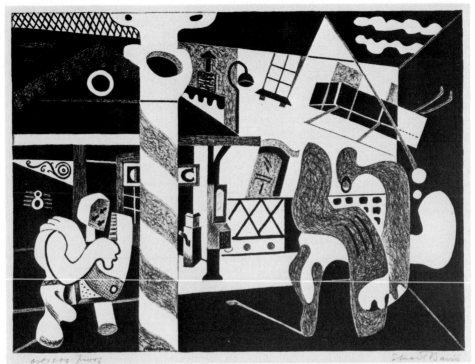

84. DAVIS *Two figures and El*

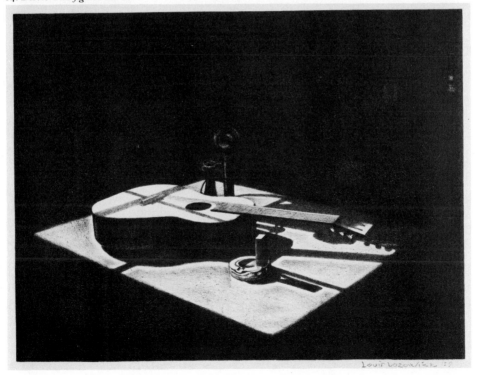

79. LOZOWICK *Still-life with guitar, no.* I

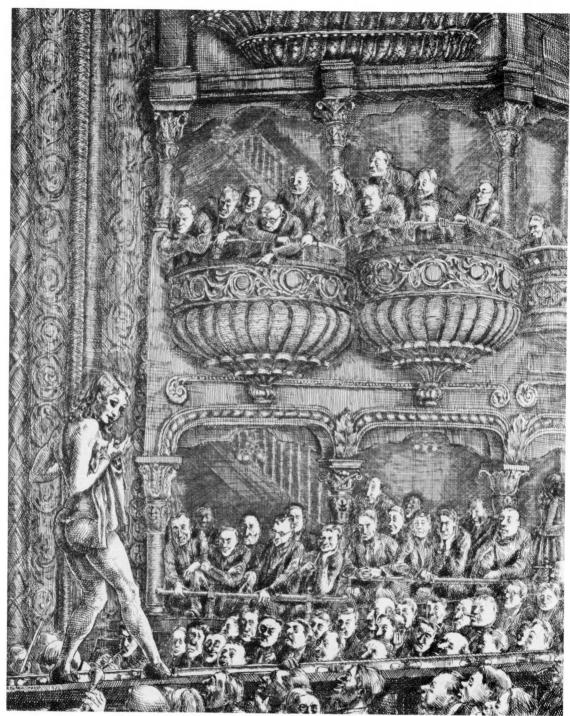

87. MARSH *Gaiety burlesque*

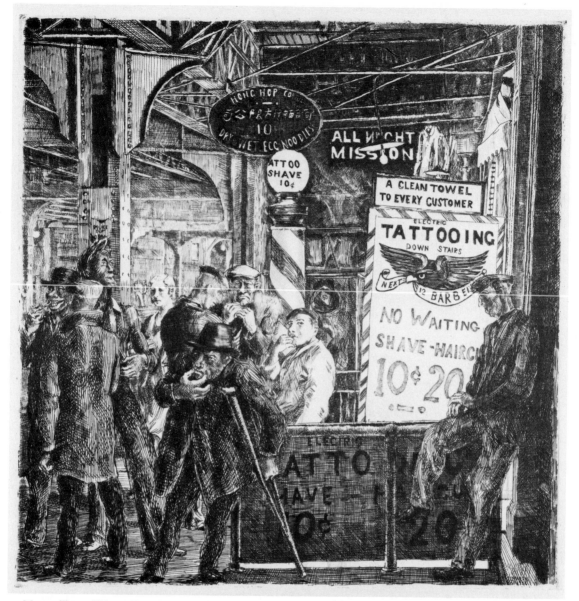

91. MARSH *Tattoo–Haircut–Shave*

93. MARSH *Eerie railroad locos watering*

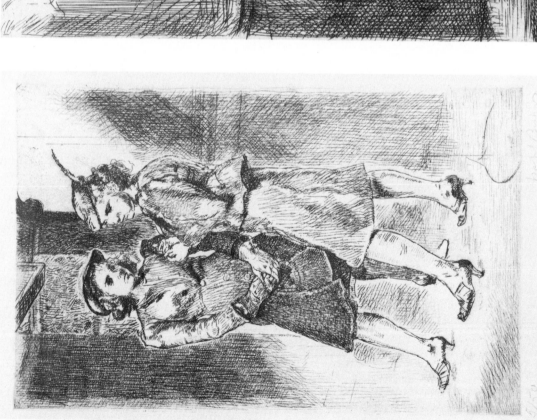

99. Bishop *Encounter*

96. Bishop *Office girls*

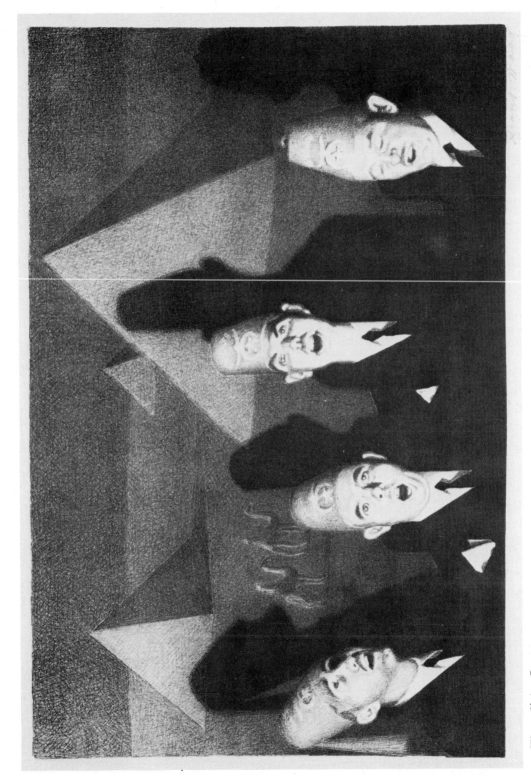

107. *Wood Shriner Quartet*

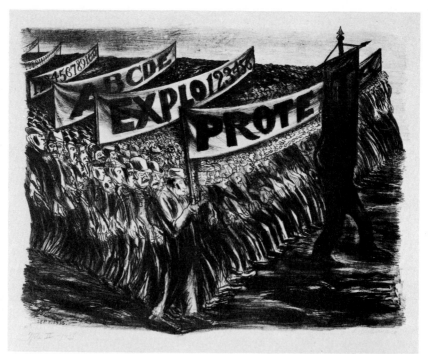

104. OROZCO *Note II* (*Manifestation*)

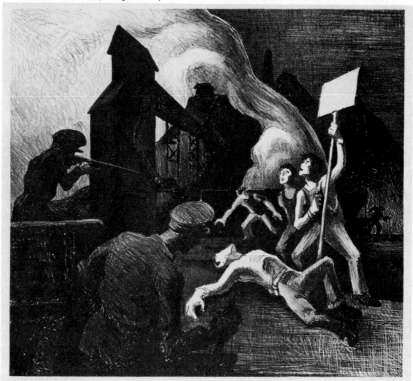

105. BENTON *Strike*

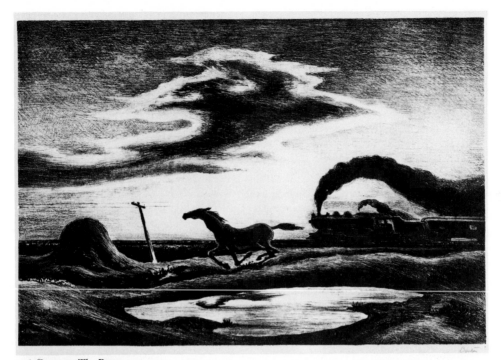

106. BENTON *The Race*

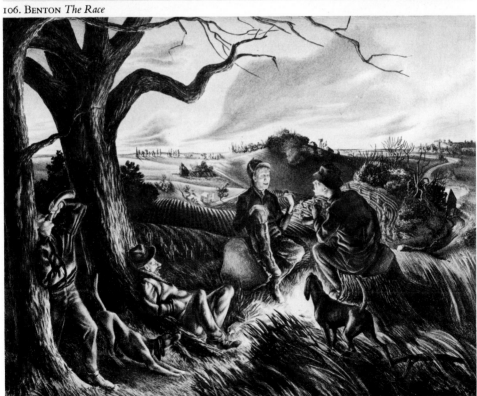

111. DE MARTELLY *Blue Valley fox hunt*

114. RIGGS *On the ropes*

117. JOHNS *Gray Alphabets*

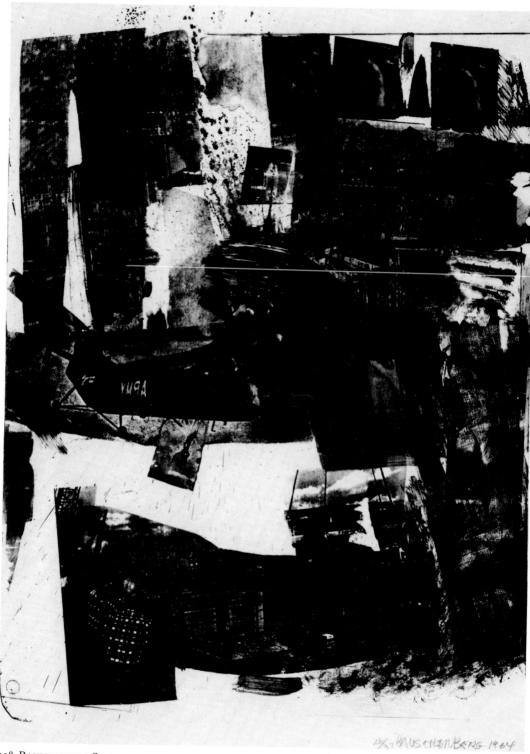

118. RAUSCHENBERG *Spot*

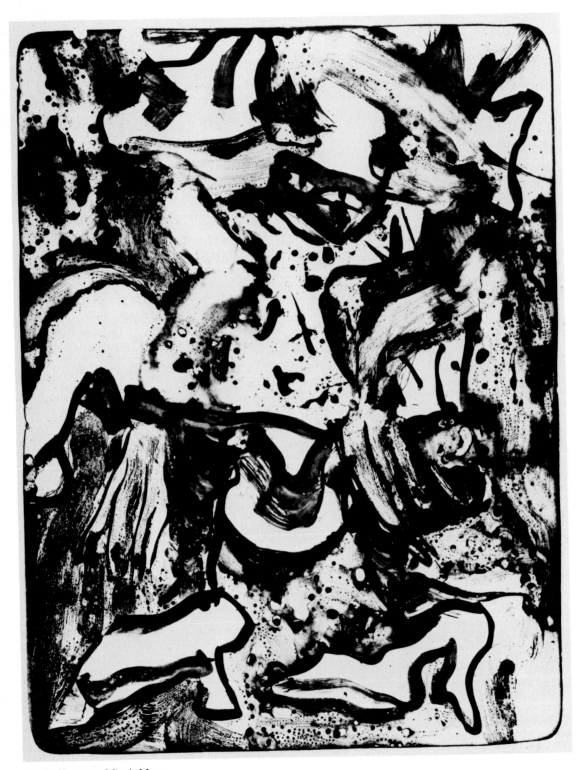

116. De Kooning *Minnie Mouse*

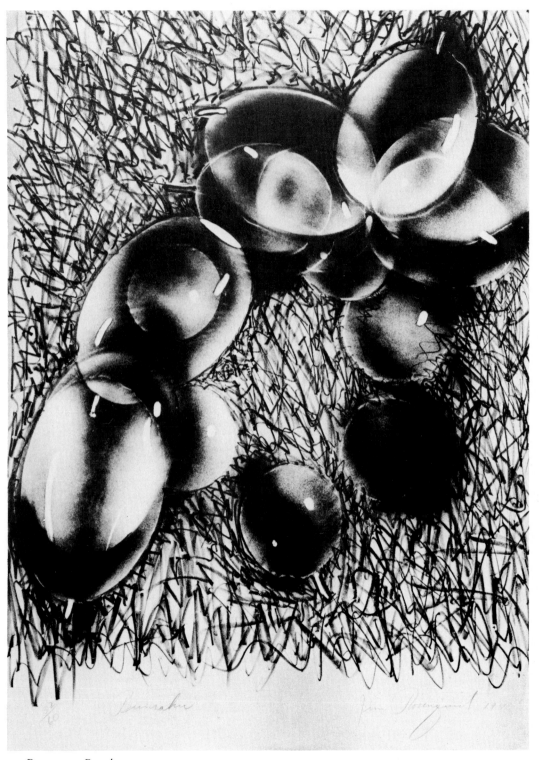

120. ROSENQUIST *Bunraku*

121. DINE *Self-portrait in zinc and acid*

123. Dine *Braid, second state*

124. DINE *Piranesi's 24 colored marks*

125. DINE *A Nurse*

129. NAUMAN *Normal desires*

128. RUSCHA *News, Mews, Pews, Brews, Stews and Dues*

132. MARDEN *Untitled, from Ten days portfolio*

130. LeWitt *Lines from corners, sides and the center to points on a grid*

134. ESTES *Untitled, 40c*